AMERICA'S PRESIDENTS

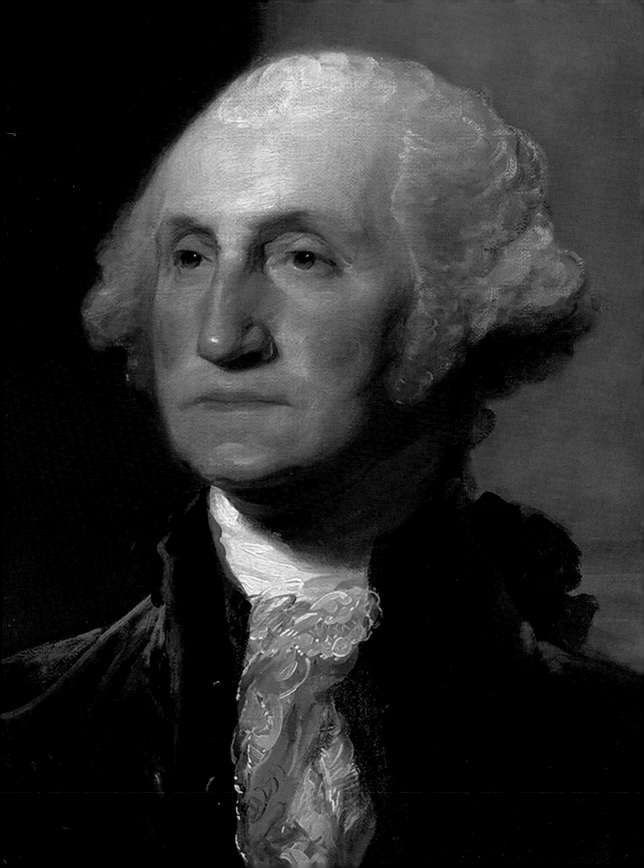

with contributions by
James G. Barber
Brandon Brame Fortune
Kate C. Lemay

Published in
association with the
National Portrait Gallery

Smithsonian Books
Washington, DC

AMERICA'S
PRESIDENTS

★ ★

NATIONAL PORTRAIT GALLERY

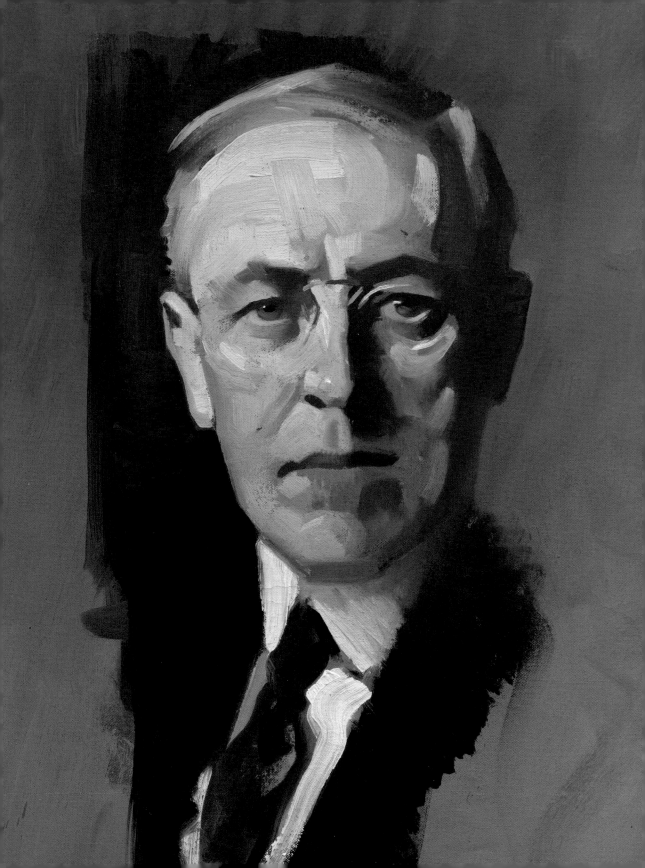

We are grateful for the generous support of those donors whose gifts were received through October 4, 2017, and to all those whose gifts followed.

Perlin Family Foundation

Philip and Elizabeth Ryan

The William T. Kemper Foundation, Jonathan and Nancy Lee Kemper

Alan and Lois Fern

Michael and Catherine Podell

Mallory Walker

Chapman Hanson Foundation

Anonymous

Mary C. Blake

Mary and Armeane Choksi

The Richard and Elizabeth Dubin Family

Dr. Ella M. Foshay and Mr. Michael B. Rothfeld

The Honorable Joseph and Alma Gildenhorn

Ronnyjane Goldsmith

History Channel/A+E Networks

Fred M. Levin and Nancy Livingston, The Shenson Foundation,
in honor of John, Jacob, and Jillian Levin

Randi Charno Levine and Jeffrey E. Levine

Dennis and Trudy O'Toole

Tommie L. Pegues and Donald A. Capoccia

Karla Scherer

Mr. Joseph P. Ujobai and Mr. Eduardo J. Ardiles

Mr. and Mrs. Jack H. Watson, Jr.

Additional support received from the American Portrait Gala Endowment.

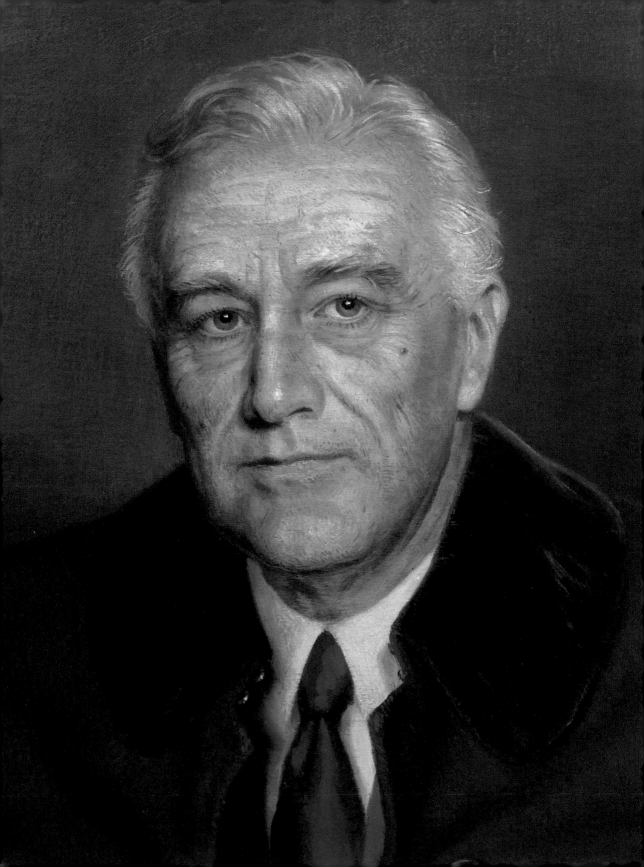

CONTENTS

Almost all presidents—whatever they have or have not achieved—
have occupied positions of enormous symbolic and cultural
importance in American life. They have become the secular icons
of the republic—emblems of nationhood and embodiments of
the values that Americans have claimed to cherish.

Alan Brinkley and Davis Dyer
The American Presidency, 2004

Accustomed as we now are to the twenty-four-hour news cycle and constant streams of online images, it seems almost inconceivable that there was a time when Americans had limited knowledge of what their president looked like. Until the introduction of photography in 1839, accurate portraits of the nation's leaders, made from life, were rare. Only in the mid-nineteenth century did the mass reproduction of photographs in the form of lithographs and wood engravings produce images of the presidents in great numbers. In the post–Civil War years, inexpensive color lithographs brought presidential portraits to private homes and campaign posters to the streets. Methods of creating portraiture and sharing images have evolved tremendously since the nineteenth century. Today, the image of the president is all but ubiquitous.

From George Washington onward, nearly every American president has taken time from his daunting responsibilities to sit for at least one formal portrait. Some presidents have formed collaborative relationships with the artists who portrayed them. Thomas Jefferson, for example, directed artist Mather Brown to show him with an air of sophistication that might impress European audiences, and with help from press photographers, Franklin D. Roosevelt managed to hide the fact that polio had left him unable to walk. Other presidents had less success in guiding the artists who portrayed them. Theodore Roosevelt, for instance, destroyed Theobald Chartan's portrait of him after he accused the artist of making him look like a "mewing cat."

Sometimes the world of the artist and the world of the president collided, as when Dwight D. Eisenhower sat for Thomas Stephens. After Eisenhower expressed his desire to understand the mechanics of portraiture, Stephens encouraged him to take up painting. More recently, George W. Bush has

become an artist, first creating portraits of his friends and family and moving on to portray military veterans. Acknowledging that portraiture provides a mere glimpse into a person's spirit, Bush noted in 2017, "Painting a portrait is never really done . . . it's a never-ending process."

Visiting *America's Presidents* at the National Portrait Gallery—the only place outside the White House with a complete collection of presidential portraits— is perhaps the most direct way to meet the men (thus far) who have occupied the Oval Office. It is appropriate, then, that we routinely reassess the narrative of presidential achievements over time. The year 2018 marks the fiftieth anniversary of the museum's public debut, and on this occasion, the reinstallation of *America's Presidents* offers fresh insight into the National Portrait Gallery's collection of more than 1,600 portraits of U.S. presidents. The exhibition, its customized website, and this publication have relied on new research and enhanced technology to tell the story of the United States through the lives of the country's leaders.

Major thanks go to the museum's historians and curators, who over time have assembled a compelling collection of portraits of the nation's former presidents in a wide range of media. I wish to express my profound thanks to all those friends who financially supported the transformation of *America's Presidents*, who are listed on the donors' page near the front of this book. Particular thanks go to the Bank of America for its early and meaningful support of the conservation of the "Lansdowne" portrait of George Washington, in 2016, and its subsequent support of educational programming in connection with the #NewCoatforGeorge debut; and to the Perlin Family Foundation; Philip and Elizabeth Ryan; and members of the Portrait Gallery Commission for their visionary financial support of the program.

The portraits in *America's Presidents* compose a visual biography of the men who have led our country. In his essay in this volume, David C. Ward adds that the depictions also serve as an armature on which to hang the national narrative. We hope that you have an opportunity to visit Washington, D.C., to see the portraits in person at the National Portrait Gallery and come face to face with history.

Kim Sajet
Director, National Portrait Gallery

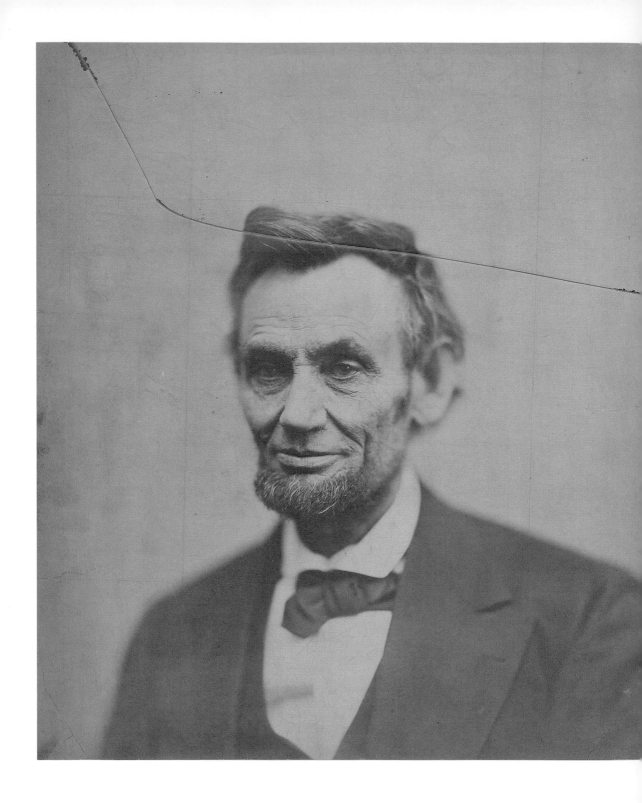

David C. Ward

The National Portrait Gallery and the White House have the only complete collections of presidential portraits, from George Washington to Barack Obama, whose official portrait is being created as we write. The official portrait of Donald J. Trump will similarly arrive at the Portrait Gallery upon the completion of his presidency. Charged with commemorating and recognizing the achievements of those who have made an impact on American history and culture, the Portrait Gallery displays likenesses of the people who have shaped the United States. While the museum is committed to telling the national story, it does so without nationalism or celebratory intent, but rather through historical engagement with the past from the perspective of the present. No mere "hall of fame" displaying the effigies of the rich and powerful to be unquestioningly admired, the Portrait Gallery offers exhibitions that are an active reflection on the history of the United States. Portraiture is the emblematic art for a society that holds out the promise, if not always the perfect reality, of individual self-advancement and achievement. It is altogether appropriate that the museum is located in the Old Patent Office Building, since the United States' greatest invention has always been Americans themselves; as the revolutionary Thomas Paine wrote, "We have it in our power to begin the world over again." This commitment to renewal and change has driven much of American history, not least in the struggle across the years for equality of rights and social justice for all segments of the population. But while the Portrait Gallery has widened the scope and definition of what it means to have contributed to American culture, the world of politics and government will always be an armature, both temporal and

Abraham Lincoln

———————

Alexander Gardner (1821–1882)
Albumen silver print, 45 × 38.6 cm (17¹¹⁄₁₆ × 15³⁄₁₆ in.), 1865
Frederick Hill Meserve Collection
NPG.81.M1

thematic, on which to organize the national narrative. A key aspect of that armature is presidential portraiture.

The authors of the documents establishing this country set general guidelines and parameters in creating the institutions of government, but they also intended a flexible structure through and by which the government could respond to events both at home and abroad. While the duties of the chief executive were not spelled out in great detail, the founders were clear that the office of the president would be only one of the coequal branches of government, with the others the two houses of Congress and the Supreme Court. This equipoise pleased a generation steeped in the ideas of the eighteenth-century Enlightenment about harmony and balance, people who frequently borrowed images and metaphors from the world of clocks and other mechanisms to show how human emotions could be regulated for the common good. This constitutional equilibrium was never likely to survive in practice, not least because the president was a singular representative of his office, whereas congressmen and judges were subsumed into groups. But more important, as historian Arthur Schlesinger has argued in *The Imperial Presidency*, the Founding Fathers intentionally left a fateful loophole in their schema: in cases of emergency or in response to urgent events, the president was allowed to act unilaterally, obtaining approval after the fact. Not all presidents were vigorous exponents of executive action, some because of ineffectuality (James Buchanan during the secession crisis of 1860) and some out of philosophical conviction (Calvin Coolidge, who believed the president should oversee just the operations of government, no more). This exception, however, has permitted the growth of executive power to the point where the president now dominates the government, partisan politics, and our wider political culture. As Schlesinger points out, Franklin D. Roosevelt was the last president to ask for a Congressional declaration of war. Since 1941, presidents have chosen to initiate conflict by executive action alone.

That the presidents are displayed in a separate exhibition at the National Portrait Gallery is indicative of their special status. Americans

now organize the nation's history by presidential term and, for better or worse, have imbued the holders of the highest office with almost supernatural power. Moreover, the charisma that envelops the office means that the president is seen as the personification of the virtues (and sometimes the vices) of American character and life. From George Washington onward, the president always has been held to a higher standard of both public and personal conduct. The challenge for the museum is to recognize the importance of the presidents and treat them with respectful critical attention but not to lose perspective and fall into hagiography. The irony of the presidential office is that it was conceived as the practical political antithesis to the divine rights of monarchs. The founders did not adopt a parliamentary system in which the chief executive would be the representative of a party or a coalition of political factions. The president—both the person and the office—was singular but the first among equals. The cliché of American social mobility, that "anyone can grow up to be president," worked the other way as well: the president was a normal, ordinary American who, by good luck and willpower, came to be the leader of the nation. The majesty of the office is always in conflict with democratic ideals, and even small acts help set the tone of an administration. For instance, Thomas Jefferson walked back to his rooming house on Capitol Hill after being inaugurated in 1800. Less successful was Richard Nixon's attempt to outfit the White House guards in ornate mid-nineteenth-century ceremonial garb. Conversely, Aaron Copland's *Fanfare for the Common Man* is a frequent choice of music for presidential inaugurations—including Nixon's.

The tensions embodied in the president, who must balance executive power and democratic politics, is apparent in portraits of the chief executive, beginning with the multitude of contemporary images of George Washington (fig. 1). Living in a media-saturated world, it is easy to forget how hungry people were to see images of public figures, especially since the pseudoscience of physiognomy promoted the idea that one could read character from a person's facial features. In Europe, portraits of rulers were explicit instruments of state power, designed to awe and

even intimidate with their large size, ornate attire, and grand poses. But ceremonial portraits in colonial America and in the early nineteenth century tended to be homely representations of members of the political class. The exception was George Washington, who was recognized as a world-historical individual very early in his public career (fig. 2). The aura around him was incontestable. He was the "essential man" of the American Revolution and the early republic, unanimously chosen as first president. Many of the major artists of his day made multiple or serial portraits of the "Father of His Country." Gilbert Stuart painted three "types" of Washington images, the most magisterial of which was his 1796 portrait. He made four versions of it; the Portrait Gallery owns the original, known as the "Lansdowne" portrait (p. 55). This full-length painting is an explicitly antimonarchical work of art. Although Stuart borrowed a pose used in European monarchical and aristocratic portraits, he subverted the conventions of the genre: Washington wears a plain black suit, not ornamental robes; he gestures to his work as chief executive, work that is supported by the practical philosophy of republican democracy (among the books under the table is a copy of *The Federalist Papers*); he bears an ornamental sword as an emblem of his role in winning the Revolution and as commander in chief; and on the desk is an inkwell shaped like Noah's ark. (The story of Noah was important to America's national self-fashioning as the place where corrupt mankind could be redeemed in a cleansed and purified "virgin land.") The space where Washington stands is fictitious, but by placing him in an office open to the elements, Stuart was able to extend the theme of redemption: the winds of change sweep the landscape clean, and a rainbow appears after the storm of the American Revolution (fig. 3).

Fig. 1. George Washington's images were so popular that they appeared on items such as this contemporary "almanack."

———

George Washington by an unidentified artist
Relief cut on paper, 1791
NPG.79.80

THE

FEDERAL
ALMANACK,

For the Year of our LORD,

1792.

Being BISSEXTILE, or LEAP-YEAR, and
the Sixteenth of American Independence.

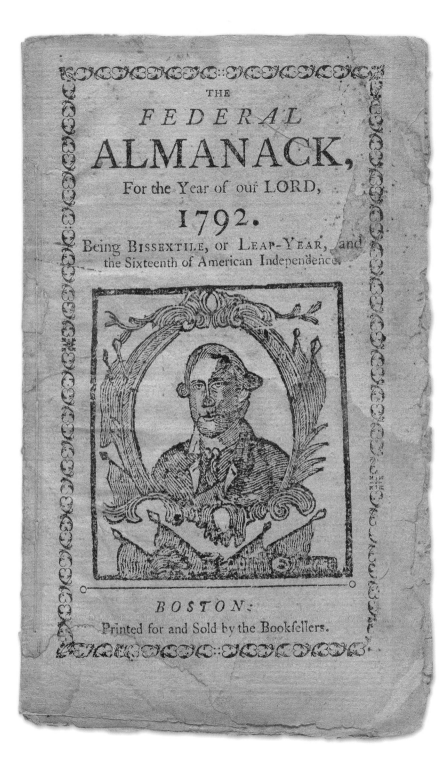

BOSTON:
Printed for and Sold by the Booksellers.

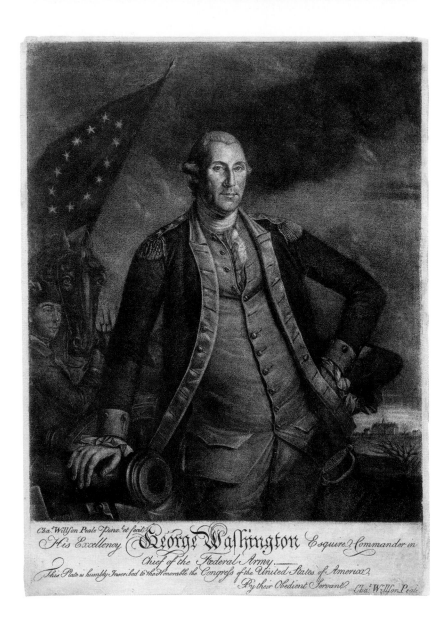

Fig. 2. Philadelphia artist Charles Willson Peale built his career on
his early images of George Washington as a soldier.

George Washington by Charles Willson Peale
Mezzotint, 1780
Gift of the Barra Foundation
NPG.76.16

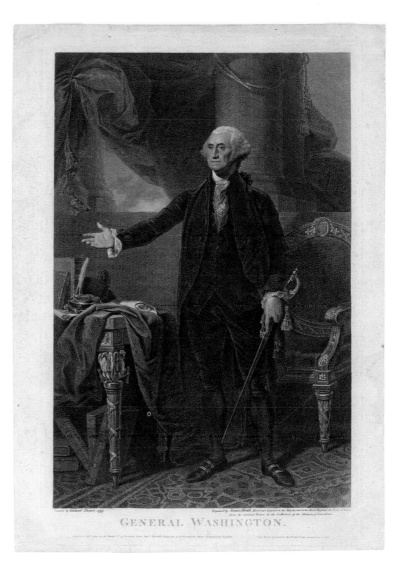

GENERAL WASHINGTON.

Fig. 3. Reproductions of Gilbert Stuart's "Lansdowne" portrait of George Washington were a way to popularize his image. After Washington's death in 1799, many more such images, such as the one above, were circulated.

———

George Washington ("Lansdowne" type) by James Heath
After Gilbert Stuart
Engraving, 1800
NPG.81.55

Washington influenced the scope and traditions of the office, not only because he was the first president, of course, but also because he served his two terms and then retired, setting the convention—later encoded in law—that a president serve only two terms. (That convention has been violated only once, by Franklin D. Roosevelt.) Stuart's magisterial image commemorated the man himself as well as the relationship among the man, the office, and the nascent United States. As an emblematic public portrait, the "Lansdowne" portrait evokes European Grand Manner painting in both its conception and its impact on audiences. It is monumental in both senses of the word, and, at the same time, it is also an outlier in presidential portraiture. As American democracy evolved in the nineteenth century, the Lansdowne approach worked when the subject was Washington but was inappropriate when the subject was a lesser figure. Even stylistically, most presidents adopted modesty and a "plain style" of portrayal. Jefferson was happy to have himself portrayed as a European dandy when he was minister to France (fig. 4), but his presidential portrait, again by Stuart (p. 67), was a model of austerity and reticence. It is a character study of the man, alone and unadorned.

One interesting exception to this rule is a very large portrait of Andrew Jackson by his "court" painter, Ralph Eleaser Whiteside Earl (fig. 5). Jackson was the progenitor of popular American democracy as the United States was beginning its expansion across the continent. While Washington had kept the contradictions of American society in check through his personal authority, Jackson personified the United States in the middle third of the nineteenth century: fractious, conflicted, strongly partisan, and violent in both word and deed. The founders had

Fig. 4. Thomas Jefferson's first portrait was created while he was serving as the U.S. minister to France.

———

Thomas Jefferson by Mather Brown
Oil on canvas, 1786
Bequest of Charles Francis Adams
NPG.99.66

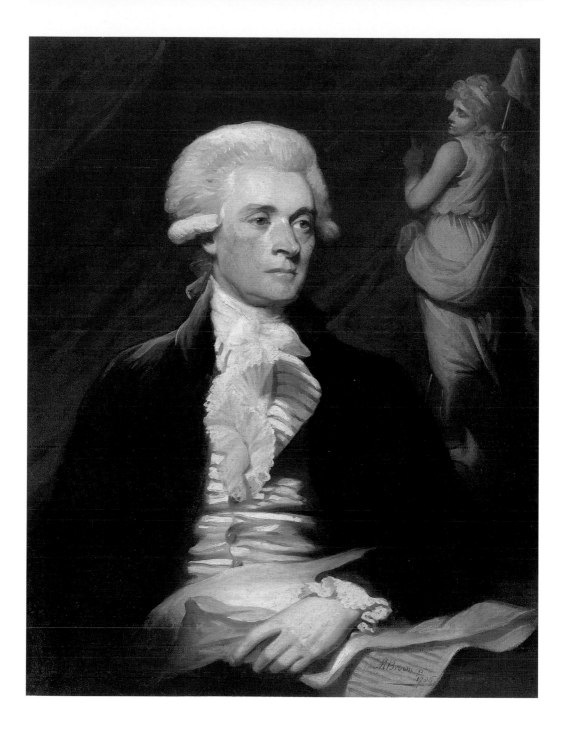

hoped in vain that their clockwork mechanism of government, along with the cooperation of like-minded individuals, would be a bulwark against both factional and personal partisanship. They would be disappointed. Politics became one of the main organizing devices in American culture as territories were organized into states and people excluded from the franchise sought the vote. Restricting suffrage proved untenable in a popular democracy, and Jackson capitalized on his humble beginnings to become the tribune of the Democratic Party. Aggressively nationalistic as well as just personally aggressive, Jackson championed the rights of the urban working class and the small farmer against what he perceived to be the oligarchic privilege of the Whig Party. Although Jackson's reputation now hangs from his policy of removal of Native Americans, for his contemporaries (and well into the twentieth century), he was the exemplar of popular democracy, giving power to the common people and enabling American individualism. Conversely, the Whigs were the party of big government, business, and regulation. Jackson's "war" over the rechartering of the Second Bank of the United States was as much a political attack on economic privilege as it was a technical economic issue. The new development in presidential leadership was Jackson's active use of executive power, utilizing his office to enhance the influence of the states and individuals. The Democratic Party, expertly marshaled by Martin Van Buren, was the popular basis for Jackson's cult of personality and a leadership style that disdained checks, balances, and precedents. Jackson was known as "King" Andrew to his enemies, yet his appeal to the populace was evidenced at his first inaugural, when

Fig. 5. Ralph Eleaser Whiteside Earl served as Andrew Jackson's "court painter," culminating in this large image of the president.

———

Andrew Jackson by Ralph Eleaser Whiteside Earl
Oil on canvas, 1836–37
Smithsonian American Art Museum, Washington, D.C.
Transfer from U.S. District Court for the District of Columbia
(1954.11.12)

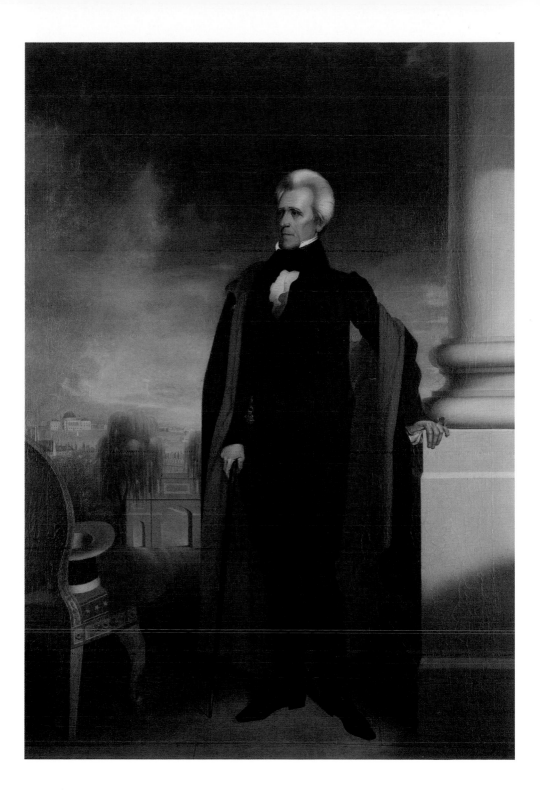

he threw open the doors of the White House to anyone and everyone; the crowds overran the mansion, causing considerable damage.

Earl's large portrait of Jackson—from his perfectly coiffed hair to the tips of his shoes—is a consummate piece of political stagecraft. By placing the president on an idealized White House balcony, with a vista of the Capitol in the background, Earl made Jackson into an elegant picture of authority and equipoise, the master of all he surveys. Although well turned out—the lining of his cloak is sumptuous—Jackson's roots in the land are signaled by the straw farmer's hat that he has placed on a nearby chair, presumably after coming in from outside. Implicitly, Jackson was the "man in the open air," a phrase used by critic F. O. Matthiessen to describe the culture of the American Renaissance (1830–50), when writers, artists, and teachers such as Ralph Waldo Emerson and Walt Whitman assessed Americans' encounter with nature. While acknowledging Jackson's roots, Earl focused on the powerful and authoritative figure of "King" Andrew. It is a portrait intentionally devoid of psychological insight or introspection in the service of its political goal: it makes Andrew Jackson seem inevitable. The smoothness of Earl's depiction also effaces all the conflict and controversy that enveloped Jackson, from his hardscrabble origins to his tempestuous relationship with other politicians (and their wives: Jackson was enraged that Washington "society" had snubbed his wife, Rachel). In Earl's portrait, Jackson is turned into a monument, one that exists uneasily with its subject's almost visceral democratic character. It is a piece of political propaganda.

Images of strong or charismatic presidents, such as Washington and Jackson, would be reproduced in etchings, lithographs, and woodcuts to be publicly disseminated in almanacs, newspapers, and journals. Washington and Jackson had the added cachet of being war heroes before they became statesmen; victorious generals always have had an advantage when running for president (fig. 6). Nevertheless, even these presidents were lampooned, satirized, and attacked in the cartoons and caricatures that gave a visual dimension to America's vigorously partisan political culture (fig. 7). The extent to which politics (along with religion—

and the two were not inseparable) animated and organized antebellum American culture is now hard to imagine. Even with all the exclusions intrinsic to a suffrage restricted to white men, political identity was a major factor in personal identity and self-assertion. Political campaigns were public festivals and entailed huge amounts of visual material, ranging from banners to broadsheets, in which images of the candidates of course figured prominently.

While popular visual culture was becoming more dynamic and exciting, the same cannot be said for American fine-art portraiture. After the late colonial and early national periods, when major artists such as Stuart and the Peale family of painters made political portraits a staple of their practice, American art went into a lull. Portraits were serviceable but little more, fulfilling a public that wanted accurate, verifiable images more than fine-art flourishes or psychological insight; portraits were biographical signposts and a virtual substitute for the sitters themselves. Aside from a few instances on the Eastern Seaboard, such as the Pennsylvania Academy of the Fine Arts, the United States lacked any kind of infrastructure to train and support artists. Urban areas in the rapidly expanding hinterland remained undeveloped artistically and culturally, whatever the aspirations of a rising middle class. And ideologically, the fine arts were seen as slightly suspect—even corrupt or effete—in this hard-headed, empirically minded society. There was a demand for likenesses, but that was about it.

Moreover, after Jackson, the presidents were an unprepossessing lot. While Congress reasserted itself as the coequal or even the superior partner in political power sharing, personal character and circumstances also played into this period of presidential "recession." Martin Van Buren (p. 79) succeeded his patron, but his temperament as a wily backroom politico was out of step with a popular politics that demanded crowd appeal. (Van Buren was notoriously noncommittal, reportedly refusing even to say that the sun rose in the East: "I rise at 10 am, so I really can't comment.") The Whig William Henry Harrison (p. 81) bid fair to succeed Jackson as a charismatic war hero turned president only to

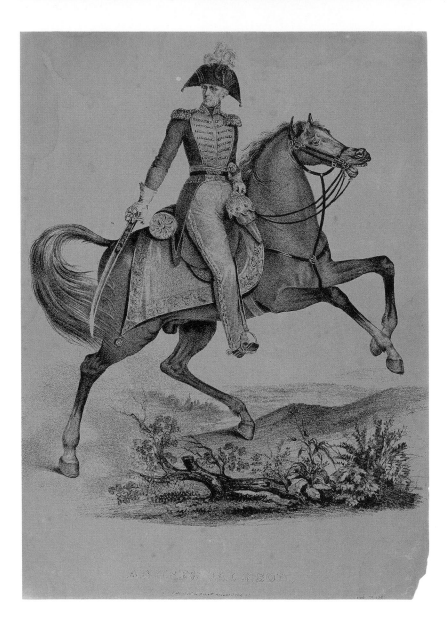

Fig. 6. Both George Washington and Andrew Jackson were war heroes before they became president.

—————

Andrew Jackson by Risso & Browne Lithography Company
Lithograph, c. 1833
NPG.79.135

Fig. 7. The 1828 presidential campaign coincided with the beginning of the lithographic cartoon in the United States, and it would soon become a staple of electioneering.

Andrew Jackson by Edward Williams Clay
Lithograph, 1829
NPG.85.66

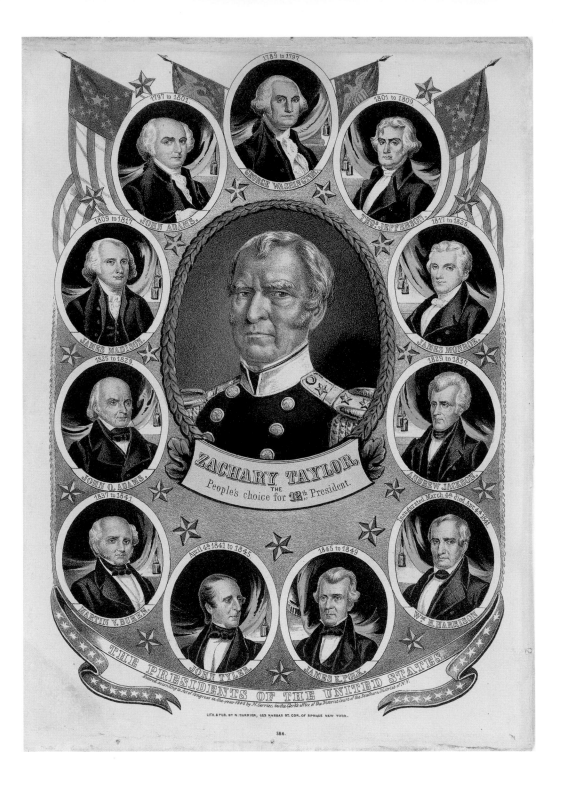

die after a month in office, succeeded by the colorless John Tyler (p. 83). Harrison's "Log Cabin" campaign did cement the tradition that presidents, however wealthy and entitled, had to have at least a common touch, if not actual working-class or poverty-stricken roots. The one effective president during this period was James K. Polk (p. 85), who governed on four issues (including expansion into the Southwest with victory in the Mexican-American War of 1846–48), achieved everything he intended, and left office after one term, as he had promised. As for the other pre–Civil War presidents, historians have called them, and the political class in general, the "bumbling generation" for their failure to defuse the impending crisis between slave and free states that would lead to secession and war. War hero Zachary Taylor (fig. 8) made a game attempt to reconcile the two regions by brokering the Compromise of 1850 but died that same year, having produced only a patchwork deal rather than a comprehensive settlement.

The absence of strong presidents during this period was in part structural and in part by political design. The national parties were essentially divided into three regions, each dominated by a powerful sectional and national politician: Daniel Webster in the Northeast, John C. Calhoun in the South, and Henry Clay—"Harry of the West"— in the Old Northwest. These men held every major office in the United States except the presidency. In presidential politics, they cancelled one another out, leaving the door open for lesser men. Calhoun was also becoming an increasingly powerful spokesman for a distinct Southern nationalism, further disqualifying him from the White House. His trajectory from a spread-eagle nationalist during the War of 1812 to

Fig. 8. This lithograph illustrates Zachary Taylor's triumph in the 1848 presidential election, with his eleven predecessors in the office surrounding him.

———

Zachary Taylor, the People's Choice for 12th President by Nathaniel Currier
Hand-colored lithograph, 1848
NPG.84.3

the "Marx of the Master Class" indicates the real problem underlying this political logjam: slavery and the growing schism between a capitalist, modernizing North based on free labor and a seigneurial, antimodern South based on slavery. From the country's beginnings, slavery was the problem that everyone hoped would somehow disappear; as Jefferson said in 1820, "We have the wolf by the ear, and we can neither hold him, nor safely let him go."

Americans recognized the ultimate philosophical and moral incompatibility of freedom with slavery, but the "peculiar institution" was simply too profitable and too engrained to evaporate. More troubling was the possibility that American freedom had depended on the expansion of slavery in the late seventeenth and eighteenth centuries, that exploitation of African slaves permitted democracy for whites. As former President George W. Bush put it succinctly at the dedication of the Smithsonian Institution's National Museum of African American History and Culture in September 2016: "Slavery was America's original sin." Penance for that sin could be avoided for only so long; in some eyes, only civil war would expiate the guilt. As the radical abolitionist John Brown proclaimed: "This land must be purged with blood," a grisly recapitulation of the story of Noah in which Brown saw himself as the avenging angel.

The consequences of the war with Mexico reopened the issue of slavery, both politically and morally. The hope that slavery had been played out as an economic system, having reached its natural geographic limits in the South, was dashed with the acquisition of huge tracts of land suitable for cotton production and plantation agriculture in the Southwest. This development complicated the careful balancing of free versus slave states to preserve equality—and stasis—in the national government. Sectional differences created schisms in the national parties, opening the way for new political groups, including the Republican Party, founded by the end of the 1850s. This highly charged political atmosphere was fueled by the fact that Americans increasingly saw slavery less as a purely political question than as a moral one—an ideological shift signaled by a change in nomenclature, from "antislavery"

to "abolitionism." For many, the contradiction between the ideals of the Declaration of Independence and the sin of slavery was finally becoming too manifest to ignore.

Abraham Lincoln's rise from Midwestern obscurity to become the Republican nominee in 1860 is one of history's more remarkable stories. It owes a great deal to Lincoln's mastery of image making and his grasp of the power of the new medium of photography. As Lincoln crafted a national persona, he used portrait photography to make himself known to the nation. When he traveled to New York in February 1860 to give his first major address to an East Coast audience, at the Cooper Union, he had Mathew Brady take his photograph (fig. 9). The image gives Lincoln, whose body was gangly and whose features were homely, the dignity and gravitas necessary for a presidential aspirant. Lincoln was no hayseed from Illinois, and the Cooper Union speech would demonstrate the subtlety and depth of his mind. The Republicans would use the Brady photograph to create political pins for the party faithful, an exciting change from hand-drawn images. The use of the new technology reinforced the Republican Party's commitment to internal improvements and an expansive economy. (Lincoln, by the way, is the only president to have been awarded a patent.)

Personally, Lincoln was almost preternaturally sensitive to cultural change, and he recognized that the modernization of the nineteenth-century economy and society meant new ways of seeing and thinking. Adept at masking his own drives and motivations, he understood that photography allowed a subject to appear before the public in multiple poses, visibly shape-shifting, like an actor playing roles. (Curiously, Lincoln's great idolater, poet Walt Whitman, made the same discovery and used photography to market himself to his audiences.) Lincoln deployed photography throughout the Civil War to present himself to the American people, as well as to demonstrate that he was on duty and that he shared with them the suffering of wartime: they could trace the war's impact in the lines on his increasingly gaunt face. The most haunting depiction of Lincoln was Alexander Gardner's "cracked-plate"

portrait (p. 10), taken on February 5, 1865, which, when seen through the lens of the assassination, seems to shimmer with foreknowledge of Lincoln's martyrdom. The president's face is careworn and grooved, and the image lacks Gardner's characteristic clarity and crispness. Lincoln seems to be disappearing from our view even as, historically, he was thinking about his second inaugural address in March, strategies for ending the war, and the problems of Reconstruction.

Politically, Lincoln had vigorously exercised his presidential power, his suspension of habeas corpus being a controversial case in point. He was also active as commander in chief, although he did not meddle in day-to-day events. He had transformed a war about the Union—his and his party's original intention and justification—into a war to liberate the slaves and give political power to African American men. With his death, plans for Reconstruction became conflicted, muddled, and ultimately unworkable, not least because of the struggle between his successor, Andrew Johnson (p. 101), and Congress. This fight ended in Johnson's impeachment, although he would not be convicted, and remained in office. The effort to reintegrate the South into the Union collapsed with federal capitulation on African American civil rights in 1877 (the result of a political bargain made in the wake of the near-deadlocked 1876 presidential election). Civil rights would be largely an issue for the states until Lyndon Johnson's "Great Society" programs of the 1960s. As with the era after Jackson, a period of executive activism was followed by a waning of presidential power. Small-bore issues such as civil service reform, the gold standard, and other technical economic issues took

Fig. 9. In February 1860, on a trip to New York City, presidential candidate Abraham Lincoln had his photograph taken in Mathew Brady's acclaimed studio.

Abraham Lincoln by Mathew Brady
Salted-paper print, 1860
Alan and Lois Fern Acquisition Fund
NPG.2011.15

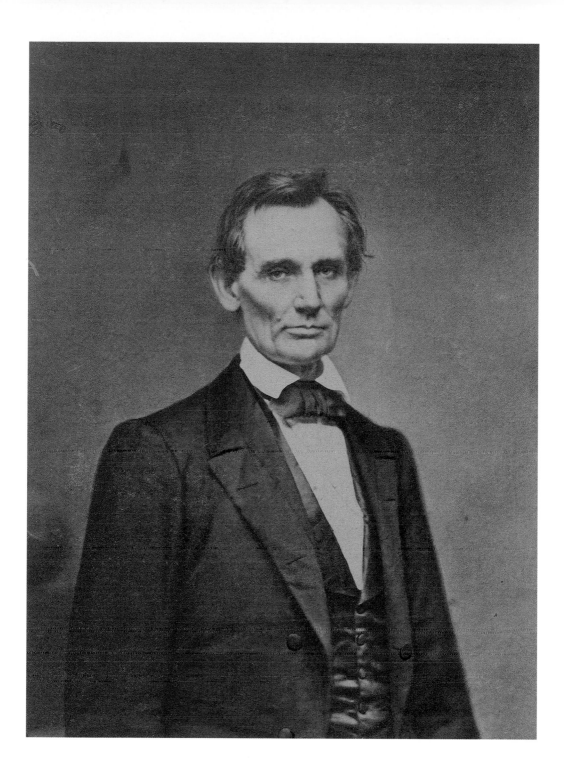

precedence. Republicans occupied the presidency and espoused a governing philosophy of laissez faire—with the exception of the very conservative Democrat Grover Cleveland (p. 111).

Mark Twain and Charles Dudley Warner would later satirize the late nineteenth century as "the Gilded Age," suggesting an appearance of prosperity and glamour that only thinly veiled an unsightly reality. The term is now used without irony, and without the writers' critical intent, to denote the prosperity and wealth of the post–Civil War period. The basic unit of the American economy changed from relatively small local entities to large corporate ones with a national reach. During this time, such familiar names as Jay Gould, John D. Rockefeller, and Andrew Carnegie consolidated their control and expanded their respective industries: railroads, oil, and steel. The growth was propelled by continuing waves of immigration, especially from Eastern Europe and Asia. This new immigration was necessary to fuel the economy, but these non–"Anglo-Saxons" would face a cultural backlash; citizenship and equality were redefined as the old WASP elite attempted to maintain its privileges. Although the idea that the new immigrant working class was infected with radical ideas—including "Red Communism" and anarchism—was overstated, it contained a grain of truth: the early labor and radical movements did have a substantial immigrant presence. In 1892, Russian émigré and anarchist Alexander Berkman attempted to assassinate the president of U.S. Steel, Henry Clay Frick. Frick survived, and Berkman was jailed for fourteen years. The violence of Berkman's attack was symptomatic of the boiling unrest that lay beneath the surface of the Gilded Age's plush furnishings. It is stunning to remember that three presidents were assassinated between 1865 and 1901. Violence was endemic in labor and political disputes; for instance, nine strikers and seven strikebreaking Pinkerton detectives were killed (many more were wounded) in a pitched battle during Pennsylvania's Homestead Strike of 1892. This type of official violence inflicted on the working class was exacerbated by the harshness of daily life for most people. The rich were getting richer, and the poor,

poorer and more desperate. The prevailing ethos of the upper classes was epitomized by Cornelius Vanderbilt, scion of the fabulously wealthy Vanderbilt transportation fortune, who proclaimed, "The public be damned." Historian Michael McGerr, in his multigenerational study of the Vanderbilts, has identified a strain of antidemocratic thought among the wealthy.

Social reform was driven by the labor movement, social welfare organizers, and muckraking journalists (with photography playing a key role in revealing the reality of life for the working class to the wider public). It also had the invaluable public support of some politicians, most significantly New York's Theodore Roosevelt (fig. 10). Although from a wealthy family, Roosevelt espoused a social conscience toward the less fortunate as well as a political conviction that American democracy would fail if society was not reformed. Energetic to a fault (after overcoming childhood asthma) and a keen observer of history, Roosevelt realized that reform had to come from above, through government action that would include the regulation of business. He would use the presidency to name and shame those who were violating his sense of fair play. He had a very old-fashioned sense of morality and correct behavior, and he instituted and encouraged practical interventions by the government into the economy and society, not the least of which was his instructing the Justice Department to break up the great business monopolies. Only a man of privilege could have called the men of his class, in his famous phrase, "the malefactors of great wealth," as Roosevelt did, and gotten away with it.

Roosevelt is arguably the most fascinatingly complex and contra-dictory character to occupy the White House. A man of action, he was also an intellectual; he probably published more works than all the other presidents combined, yet he also enjoyed challenging guests to impromptu boxing matches. (He suffered a very serious eye injury in one bout.) An enthusiastic hunter, he was also a naturalist in an era when the two roles were not at odds; he was a driving force in setting up the national park system. Possessed of all the ethnic and racial prejudices

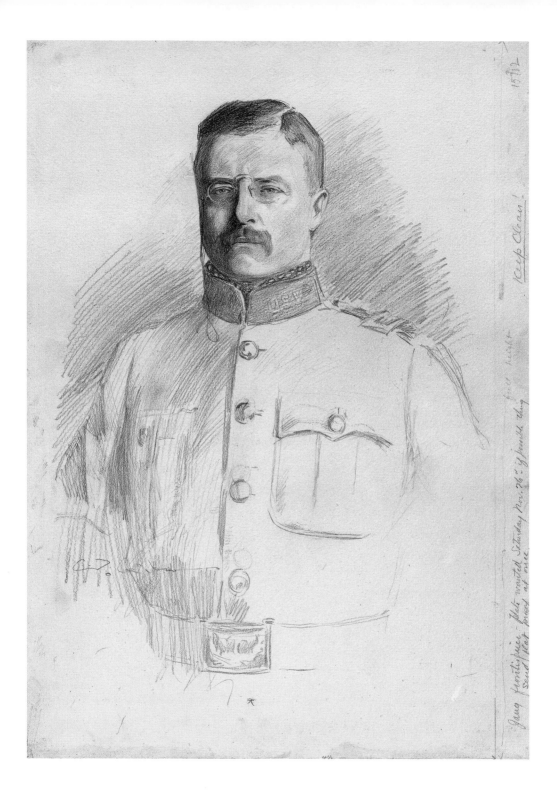

of his class, he could transcend them in a magnanimous gesture, such as having African American Booker T. Washington come to dinner as one of his first guests at the White House in 1901. A nationalist and an imperialist—he sent the navy's "Great White Fleet" on a trip around the globe in 1907 as a mark of America's world power—he was awarded the Nobel Peace Prize that year for mediating the end of the Russo-Japanese War. He was ceaselessly in motion, driven by the sense that his life would be cut short (it was: he died at sixty) as well as a sense of his own destiny to do great things. He suffered the tragedy of losing his wife and mother on the same day in 1884 and blotted out that entire day in his diary as a sign of his mourning and grief. He made sure thereafter that his days were always filled. Ironically, he became president because New York's Republican Party tired of dealing with his disruptive presence as governor: its operatives conspired to make him vice president, and he ascended to the presidency upon William McKinley's (p. 115) assassination in 1901.

The first president of the twentieth century, and the youngest ever, at age forty-two (John F. Kennedy was the youngest elected, at forty-three), Roosevelt was also the first chief executive to truly capitalize on the new world of media. He did so in pursuit of an energetic exercise of presidential and governmental authority to reform the conditions of life. Despite his wealthy background, Roosevelt particularly targeted big business in ways that were unprecedented, initiating a series of legislative and legal measures to improve corporate practices, including reining in the power of the trusts and monopoly capitalists. Roosevelt's dynamic personality was the public face of what became known as the

Fig. 10. Charles Dana Gibson's portrait of Colonel Theodore Roosevelt, published in the January 1899 issue of *Scribner's*, illustrated the first installment of Roosevelt's memoir *The Rough Riders*.

———

Theodore Roosevelt by Charles Dana Gibson
Graphite and conté crayon on paper, 1898
NPG.73.35

Progressive movement. Not only was he an indefatigable writer for the press and magazines, his life was thoroughly documented in photographs and films. He was five foot ten, barrel-chested, and a magnificent subject for caricaturists and cartoonists, with his mustache, pince-nez, and those iconic teeth bared in that trademark Roosevelt grin—a smile that could signal amusement or ferocity, and sometimes both at the same time. His formal presence and authority come to life in the paintings and drawings of him by the artists of his day, including John Singer Sargent's full-length portrait from 1903. But it is in the photographs that one senses the vigor of the man, not least when he was on the hustings in full campaign mode. By the turn of the century, the convention that politicians would not speak on their own behalf was breaking down; Democratic nominee William Jennings Bryan personally campaigned against McKinley in 1896, and Roosevelt's stump speeches were captured not only in still photography but also in the herky-jerky images of early films and in sound recordings. The media presidency was at hand.

Technically, because Roosevelt had been elected only once in his own right, he could have run again for president in 1908 without violating the two-term "rule" in place since Washington. But he graciously stepped aside for his chosen successor, William Howard Taft (p. 121), who shared his trust-busting zeal, if not his advocacy of the strenuous life. (Taft, to be kind, was large.) But Roosevelt was unable to stay offstage. His hunting and scientific expedition to Africa in 1909 was supposed to shift the spotlight onto Taft, but it was covered extensively by the media, and the trip was followed by a speaking tour of Europe in which the ex-president assessed the dire world situation. Impatient with Taft, whom he perceived as too slow to advance the Progressive program, Roosevelt ran as a third-party candidate on the Progressive "Bull Moose" Party ticket in 1912, splitting the Republican vote and enabling former Princeton University academic and New Jersey governor Woodrow Wilson to become the first Southern president since before the Civil War. (Wilson was born in Virginia and caught a glimpse of Robert E. Lee when the general was in Atlanta in 1865.)

The posthumous reputation of a president rises and falls, a process governed by the perspective of distance and by shifts in the culture. As noted, Jackson was once almost entirely revered for his symbolic and actual role in expanding American democracy and for being the representative of the "common man." That standing is now colored by his treatment of Native Americans as well as the basic aggressiveness, even violence, of his personality. Theodore Roosevelt was an imperialist fully committed, both culturally and politically, to the "white man's burden" when that point of view was prevalent; by the end of the twentieth century, such a stance would become untenable. Wilson's reputation has undergone a severe reevaluation, perhaps the most drastic reversal experienced by any president. Once seen as a liberal internationalist of an almost saintly, idealistic temperament, he now has been reassessed in light of his views on race and civil liberties. Wilson's presidential reputation was built on his attempt to adjudicate the end of World War I and create a new world order based on principles and reason rather than power politics; his "Fourteen Points" argued for an entirely new system of international relations, as did his advocacy of the League of Nations. Born of optimism, Wilson's visionary program went unfulfilled, and during his cross-country campaign to rally support for the league against isolationist opposition, he suffered a stroke that left him largely incapacitated. Long seen as a tragic figure, almost too good for the world of cynical statesmen and conniving politicians, Wilson is now judged by his hostility to African American civil rights (he resegregated the army, for instance), his antipathy toward women's suffrage, and his suppression of civil liberties during World War I. In any case, Wilson is a good example of a strong president who did not necessarily have a fiery or charismatic public presence; the Portrait Gallery's presidential portrait (p. 123) shows him as calm and cerebral.

With Wilson's departure and his succession by the handsome, jovial, and ineffectual Warren G. Harding (p. 125), the Progressive Era came to an end, terminated not just by compassion fatigue but by its own ideological and moral overreach. The contradictions of the time are

evidenced in the nearly simultaneous ratification of the Constitutional amendments granting women the right to vote and forbidding the sale of alcoholic beverages. Enfranchising women was the culmination of a long struggle that had gained urgency at the end of the nineteenth century, especially as women assumed prominent positions in society and culture; it acknowledged the reality of the redefinition of modern womanhood. Conversely, Prohibition was driven largely by a wave of antimodernist resistance from more traditional segments of the American population, including religious fundamentalists. In this instance, the regulation of behavior and hence morality through a constitutional amendment proved unworkable and had the ironic consequence of unleashing a crime wave in the 1920s related to the provision of illegal liquor to a thirsty American public. Prohibition, probably the biggest single public policy fiasco in American history, was repealed in 1933. Its failure was an indication that there was no rolling back the impact of modernity on society and government.

The "call and response" between the president and the American people—the use of what Teddy Roosevelt called "the bully pulpit" of the presidency—was key to the evolution of the office and the nation. Activist presidents built on precedents established by their predecessors, especially in justifying executive action in advance of Congress or state governments. The provision emplaced by the Founding Fathers that the president had to be able to respond to emergency or crisis situations provided constitutional cover for the unilateral intervention of the executive. In a complicated society and an interconnected world, what constituted an emergency was often unclear, but the inclination was toward activism. Politics, like nature, abhors a vacuum, and once set in motion, the momentum for the president to act in cases that previously might have violated the separation of powers was all but unstoppable.

The rise of mass media exponentially increased the charismatic power and authority of the presidency. The revolution in visual presentation that began with Lincoln's exploitation of photography was now fulfilled by the ubiquity of the camera and the advent of film. Any sense that

the president should be a distant, remote figure had now disappeared. Teddy Roosevelt was temperamentally incapable of sitting still, but he inadvertently created the precedent that presidents always need to appear to be busy. As President George W. Bush would say in 2003, "We have a responsibility that when somebody hurts, government has got to move."

Calvin Coolidge was the last genuinely philosophical conservative to serve as president (fig. 11). Known as "Silent Cal" for his taciturnity, he was equally reticent in his view of government, arguing for a caretaker presidency in which people would solve problems for themselves. (For a brief period in the 1970s, Coolidge became a hero of the New Left for his espousal of a nonstatist, nondirective approach to government that gave "power to the people"; the moment passed.) Coolidge was an interesting anomaly succeeded by the more traditionally Republican Herbert Hoover (p. 129). With the Great Depression—which occurred on Hoover's watch, although it is not clear he could have done anything about it—sixty-five years of Republican ascendancy were washed away by Franklin Delano Roosevelt's landslide victory in 1932. There is a revisionist conservative argument among historians that Hoover was doing everything that Roosevelt would do and hence does not deserve the blame heaped upon him by both contemporaries and posterity. Perhaps, but the view that a Republican was acting like a Democrat is a rather telling indictment of Republican ideology. Regardless, circumstances matter, and Hoover, whatever his plans, was the victim of them. With the second Roosevelt, Theodore Roosevelt's distant cousin, the parameters of the "Imperial Presidency," as Schlesinger has termed it, would be firmly in place and seemingly unalterable. Whether Republican or Democratic, conservative or liberal, the power of government flowed from the White House; the other branches and the states followed but did not lead.

Franklin Roosevelt came from the less socially prominent and wealthy side of the family, unlike his cousin Teddy, but he still exemplified a patrician background that he had to overcome in order to succeed in electoral politics. While he inherited his class's commitment to public service (the law or business were the only alternatives, and they didn't

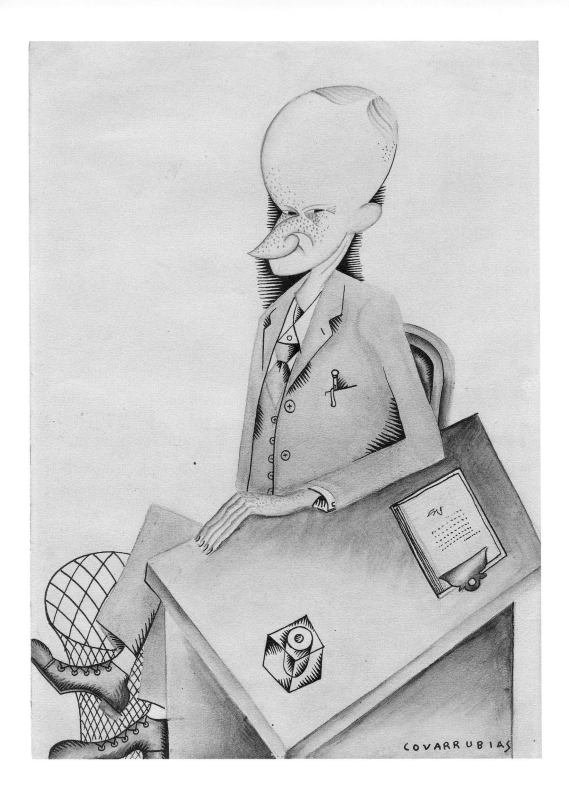

appeal), the defining event that transformed his somewhat aimless career track was his contracting polio in 1921. The disease left him unable to walk or stand without braces. The challenge of managing without working legs hardened Roosevelt physically and, more important, mentally; his infirmity made him focus on making his life meaningful and enhanced his already natural sympathy for the underdog and the unfortunate. Roosevelt's loss of mobility also helped shore up his marriage, which had been threatened by Eleanor's discovery of an affair. The couple maintained the marriage, but thereafter it became a political partnership in which Eleanor served as Franklin's "legs," traveling to represent him and in service of the Democratic program (she was much more liberal than he was).

In terms of his public image, Roosevelt minimized the effects the disease had had on him. His public appearances were stage-managed so that his infirmity was hidden, and a compliant press abetted the president's reticence (fig. 12). This lack of coverage was not an overt cover-up or suppression of the news but a genuine sense—since disappeared in the wake of revelations about Wilson's, Roosevelt's, and Kennedy's health issues—of the distinction between public and private lives. The president's health was once considered private business. The issue is a contentious one: aside from physical or mental issues affecting the president's capacity to perform the duties of the office, there is a tension between the public's need to know and the political demand that the president appear to be inviolable and without weakness. The president is not permitted to be incapacitated either actually or symbolically.

For Roosevelt, who was naturally sociable and convivial, demonstrating that he was strong enough to be president despite having polio

Fig. 11. Something about the taciturn President Calvin Coolidge invited both verbal and visual parody, and Miguel Covarrubias created one of the more merciless caricatures of him for *Vanity Fair*.

Calvin Coolidge by Miguel Covarrubias
Watercolor and ink over graphite and colored pencil on paper
c. 1925
NPG.79.76

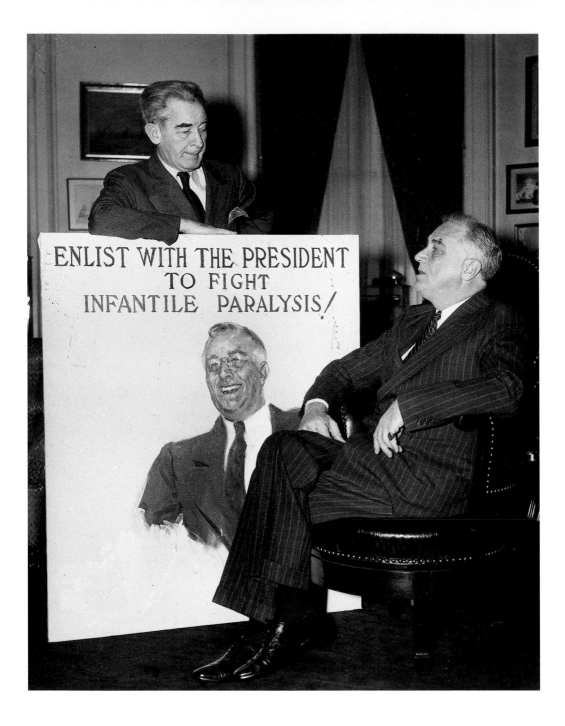

meant that he became theatrically ebullient in public appearances. He had a wonderful speaking voice, which he used to great effect, not least in his "fireside chats," in which he used national radio to speak directly to the American people, creating a bond of intimacy that was reassuring but also enhanced the charismatic power of the office. When Roosevelt turned up the rhetorical volume, he was a startlingly effective political speaker, skewering his rivals, both foreign and domestic. His only rival as a speaker was probably Winston Churchill, but the Englishman still exemplified the attitude and ornate cadences of the late Victorian era. Roosevelt was completely modern in his ability to change and modulate his speech depending on the audience, issue, and occasion. He also knew how to strike a pose, a skill he had learned to compensate for his lack of mobility. He had a large, leonine head and distinctive features that he augmented with props such as pince-nez eyeglasses and an ivory cigarette holder that would jut out of his mouth at a jaunty angle. But personally, Roosevelt concealed as much as he revealed. The mask of his public persona hid a complicated, driven, and manipulative personality, one that was certainly not as affable as the sunny face he presented to the public; he was both the lion and the fox, in the words of biographer James MacGregor Burns.

The enormity of the crisis between 1929 and 1945 required almost ceaseless pragmatic action, not least because there was no blueprint to recover from a global depression or to wage a truly global war. Doing so necessarily entailed a huge expansion of executive power and authority. Retrospectively, there has been an attempt by journalists and historians to see the Roosevelt years as much more ordered and planned than they actually were. Roosevelt himself never made any secret of his basic

Fig. 12. In 1938, Franklin D. Roosevelt helped launch the National Foundation for Infantile Paralysis, later known as the March of Dimes. Roosevelt had contracted the disease, now called polio, in 1921.

James Montgomery Flagg and Franklin D. Roosevelt by an unidentified photographer
Gelatin silver print, January 28, 1939
Acquired through the generosity of David C. Ward
NPG.2016.21

pragmatism: try something, and then try something else if that doesn't work, but government could not afford to be idle. This belief led him into one of the few legitimate constitutional crises of the twentieth century: after the Supreme Court struck down several key pillars of the New Deal as unconstitutional, an angered Roosevelt threatened to "pack the court," adding compliant judges to get the majority he needed to approve his actions. The sense of crisis, combined with his landslide victories and large congressional majorities, had led Roosevelt to make a rare misstep. The mask had slipped, and the capriciousness of Roosevelt's response invited comparisons not only with "King" Andrew Jackson but also with Europe's dictators. Roosevelt backed down, and a showdown between the executive and the judiciary was averted.

A judicial limit had been set during the court-packing crisis, but the growth of executive power at the expense of the other branches of government did not abate. It was only accelerated, in fact, by war and the actions of the president as the commander in chief of the armed forces. War is the great incubator of presidential power. Most obviously, war or the threat of war permitted Roosevelt to violate the two-term "rule" and run for office a third time in 1940 on the basis that the crisis was too dire to permit a change of personnel and administrations—an argument made again in 1944 to justify a fourth term. After Roosevelt, a constitutional amendment would cap presidential terms at two, legally codifying what previously had been custom.

Term limits were directed at an individual, not at the office of the presidency and its dominating position atop the structure of governmental power. The Cold War and the threat of nuclear war only ratcheted up the sense that the executive needed to have a free hand in case of an imminent crisis—either to defuse it or to respond if an all-out war was launched. Moreover, the exigencies of the Cold War led the executive to take charge of or create entirely new agencies in order to streamline decision making or to get around what had become a labyrinthine federal bureaucracy. The wartime Office of Special Services (i.e., espionage and counterespionage) morphed into the peacetime Central Intelligence

Agency. Later, the National Security Agency would gain power at the expense of the State Department. During the Cuban missile crisis, President John F. Kennedy set up the ExComm (for Executive Committee) team out of the National Security Council to further narrow the decision-making process. Expediency ruled. The current welter of post-9/11 offices concerned with security issues is nearly impossible to chart; that many of these agencies are classified "secret," with their budgets off the books, makes understanding executive power even more difficult.

The postwar presidents have not approached the stature of any of the previous "strong" presidents—Washington, Jackson, Lincoln, and the two Roosevelts—who materially changed and expanded the power and scope of the office, making it superior to the other two branches of government. Nonetheless, they inherited the powerful position, along with the burden of the great expectations that have evolved along with the nation itself. The history of the presidency exists in symbiosis with the history of American democracy, not least because the president simultaneously reflects the present and points to the future with his reactions to the issues of the moment. Lincoln said that he had to admit that he did not control events but that events had controlled him. Presidents have tended to fare better when they have acknowledged the truth of Lincoln's words. Executive overreach—the attempt to control events—has been the main cause of disappointing or failed presidencies.

It would be interesting to see how the Kennedy administration would have developed had the president not been assassinated. Kennedy ran in 1960 as a conservative Cold War Democrat, carrying his message in an image of youthful energy (fig. 13). His inaugural address was essentially a call to arms that committed the United States ("pay any price, bear any burden") to engage around the world economically, culturally, and militarily, as in the rising conflict in Vietnam. This clarion call ratcheted up the atmosphere of continual crisis and positioned the executive as the rapid response force to meet challenges as they arose. Kennedy's was succeeded by two administrations that stylistically and programmatically followed the Cold War liberalism of the Roosevelt-Truman era. Lyndon

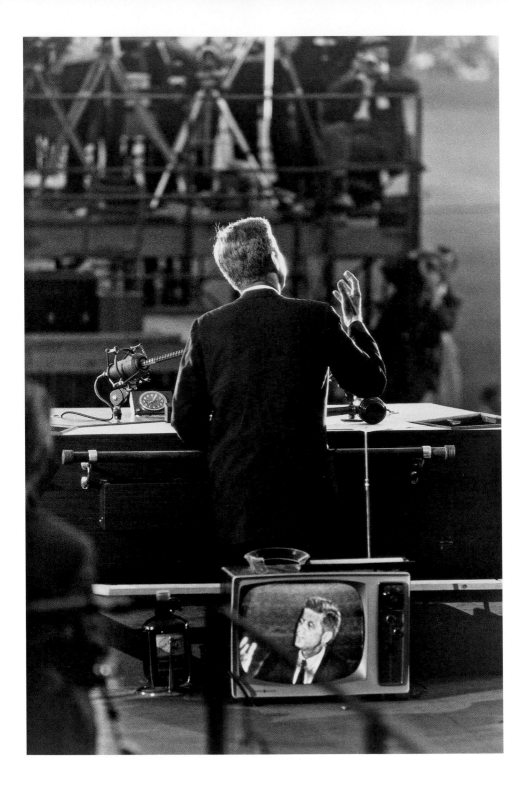

Johnson's (p. 145) ambitious domestic program—the Civil Rights Act of 1965—completed the unfinished work of Reconstruction but was essentially overshadowed by his escalation of the war in Vietnam, which ultimately brought him down politically. Although Richard Nixon (p. 147) was an extreme partisan as a politician, he governed as a big-government Cold Warrior. A difficult, complicated, and secretive man, Nixon had an obsession with control that led to his downfall against the background of Vietnam, both in terms of the war itself and the social divisions it unleashed at home. Nixon resigned his office when threatened with impeachment over the White House's responsibility for and cover-up of the Watergate break-in.

The fervid atmosphere of the Johnson-Nixon years ended not only because of America's withdrawal from Vietnam, but also because subsequent presidents realized they had to scale back the extent of their programs and remain politically connected with the public. Ronald Reagan (p. 153) had an extremely ambitious plan in office, but he concentrated on reducing the size of government and confronting the USSR, did not become administratively or bureaucratically distracted, and presented an optimistic face to the American people. Reagan had an intuitive sense of the public, including the historical tradition of American exceptionalism that played well after a lengthy period of social turmoil and scandal. Interestingly, his predecessor, Jimmy Carter, had attempted to dial back expectations about the power of the president, asking—not unlike Calvin Coolidge—that the American people look to themselves for solutions to society's problems. Reagan ruthlessly exploited this self-questioning as weakness and lack of confidence, crushing Carter in the 1980 presidential

Fig. 13. This double portrait of John F. Kennedy accepting the Democratic presidential nomination calls attention to one of the most historic developments associated with the 1960 election: the introduction of television as a medium of mass communication.

John F. Kennedy by Garry Winogrand
Gelatin silver print, 1960 (printed 1983)
NPG.84.18

election and ushering in a period of Republican ascendancy. Carter's presidential portrait (p. 151) is an interesting study in that it departs from the usual visual vocabulary of self-assertion seen in such pictures to show a diffident man (the beige suit stands out in a sea of dark clothing) seemingly lost in the space of the Oval Office.

The denouement of the Cold War, which played out under Reagan and his successor, George H. W. Bush (fig. 14), put an end to the bipolar world that had set the terms of presidential politics since 1945. It did not result, as many had hoped, in either a peace dividend for the economy or an end to crises. There was a brief interlude in Bill Clinton's (p. 159) administration in which the president reportedly bemoaned the fact that he did not live in challenging times and thus could not achieve a "legacy," like his hero John F. Kennedy. (The lack of a sustained period of crisis to occupy him may have contributed to the sex scandal, and its extensive media coverage, that led to his impeachment.)

Today, in the chaos of post-9/11 foreign policy and a succession of regional wars and international terrorism, many long for the comfortable structure and certainty of great-power politics. The micronationalism of the current world situation and the reappearance of religion as a driver of nationalist insurgencies have become potent obstacles to more developed societies. The United States has been in a state of armed conflict since 2001, with no end in sight; in the meantime, reflexive air strikes have become the default response to flare-ups. At home, the culture wars, especially over issues of gender equity, show no sign of abating and indeed may have intensified precisely because America's role in the world is uncertain. Casting al-Qaeda and militant Islam as an existential threat to the United States has led to tensions at home, especially in regard to civil liberties. The multiplicity of agencies tasked with homeland security indicates the seriousness of the ongoing problem, if not the efficacy of a solution. As Ronald Reagan pointed out, nothing is harder to kill than a governmental program after it has begun. It is unlikely that these agencies will disappear once the current situation changes.

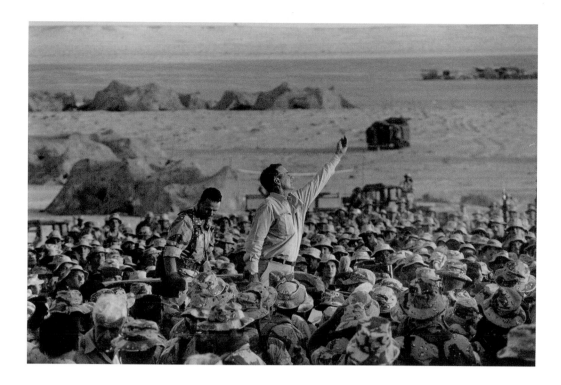

Fig. 14. *Time* magazine photographer Diana Walker captured
President George H. W. Bush during his Thanksgiving visit to
American troops stationed in Saudi Arabia just before the
start of the Gulf War.

George H. W. Bush by Diana Walker, chromogenic print, 1990
Gift of Diana Walker
NPG.95.108

The presidency of Barack Obama (fig. 15), the first African American
chief executive, ended in January 2017, and his official portraits are being
created for both the Portrait Gallery's and the White House's collections.
As with all "contemporary" history, it will require time to better assess
Obama's presidency in the context of both the present situation and
the history of the presidency itself. The surprising result of the 2016
presidential campaign, which saw the election of the political outsider
and maverick Donald J. Trump, will not just impact how we view the

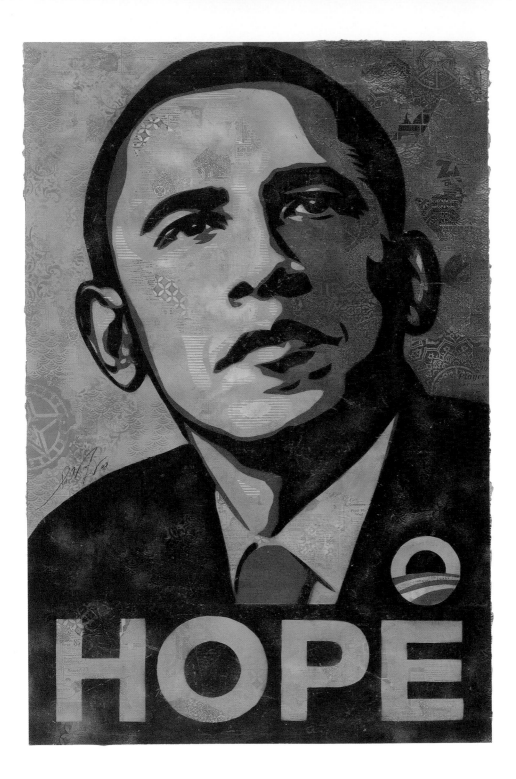

HOPE

Obama administration but also might mark a sea change in political culture if the Trump administration succeeds in acting on its rhetorical claims. The president vowed to implement an antigovernment program, which would deconstruct the liberal consensus on social welfare efforts that have been in place since the Great Society of the 1960s. Trump won the election by tapping into a broad populist streak of anger that had been building for decades, one that saw the government as out of touch with the American people, serving only privileged elites, and incapable of solving even the most basic civic problems.

With his pledge to "Make America Great Again," Trump fused his domestic campaign to a powerful, if inchoate, public sense that the country's place in the world had slipped since 9/11 and the subsequent wars against nation-states and "terror." Trump's rhetoric encapsulated a sense that the government (and the governing "classes," epitomized by his opponent, former First Lady, Senator, and Secretary of State Hillary Rodham Clinton) had let America and Americans down. He made a direct appeal to American nationalism—a nationalism that was not simply aspirational but relied on the idea of asserting blunt political and military power to order the world. Moreover, in his use of social media and his disdain for the institutions of American politics and government, Trump may well mark a new era for the presidency: an authoritarian chief executive whose power derives from his personality alone. The beginning of any new presidency is always a transition and a turning point. Whether the inauguration of Trump as the forty-fifth president introduced a completely new style of executive governance, one that will dramatically reshape our politics, remains to be seen.

Fig. 15. Shepard Fairey's Barack Obama "Hope" poster became the iconic campaign image for the first African American president of the United States.

———

Barack Obama by Shepard Fairey
Hand-finished collage, stencil, and acrylic on heavy paper, 2008
Gift of the Heather and Tony Podesta Collection in honor of Mary K. Podesta
NPG.2008.52

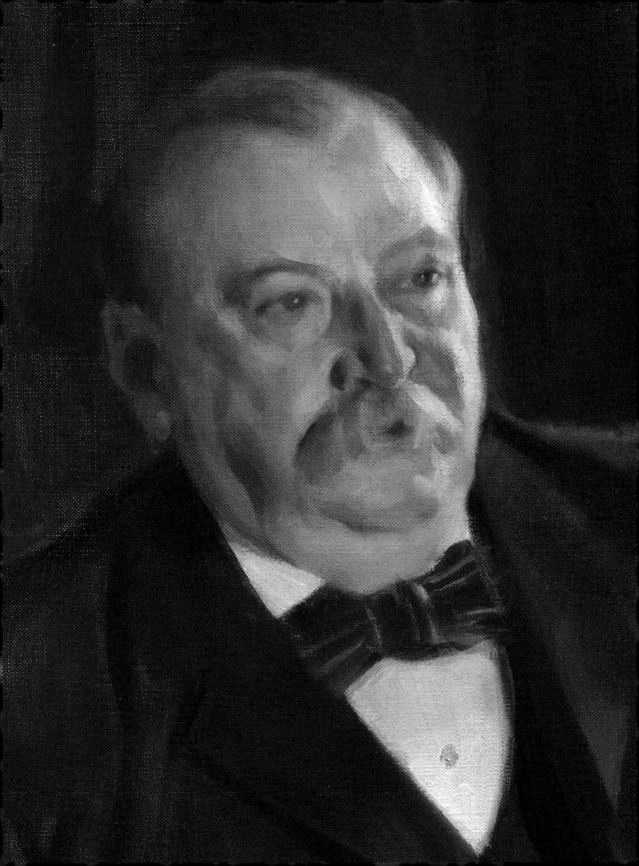

THE PORTRAITS

Grover Cleveland (detail)

————

Anders Zorn (1860–1920)
Oil on canvas, 121.8 x 91.4 cm (47^{15}⁄$_{16}$ x 36 in.), 1899
Gift of the Reverend Thomas G. Cleveland
NPG.77.229

GEORGE WASHINGTON

George Washington played an instrumental role in the founding of the United States. His stature and charisma as a military and political figure made him a unifying force during and after the Revolution. A Virginia planter at his beloved Mount Vernon, he was also a professional soldier, gaining experience during the French and Indian War and serving as commander in chief of the Continental Army during the Revolutionary War. Washington was the inevitable and unanimous choice as the first president of the United States, and he brought his leadership experience to all the unprecedented responsibilities that came with the office: installing the Supreme Court and the cabinet, quelling the Whiskey Rebellion, and defeating the Western Lakes Confederacy in the Northwest Indian War (and later negotiating a peace settlement with the alliance). Although he enjoyed immense popularity at the end of his second term, he declined to run again, insisting that the United States needed to take precautions to avoid hereditary leadership and dictatorship in the future. His death in 1799 caused universal mourning.

Gilbert Stuart's iconic image of Washington draws on European traditions of state portraiture and references the president's military and civic leadership in his pose, sword, and formal black velvet suit. The composition is often thought to evoke the moment when Washington addressed Congress in December 1795 in support of the Jay Treaty, which resolved lingering tensions between Britain and the United States. Pennsylvania Senator William Bingham and his wife, Anne, commissioned the painting in the spring of 1796 to celebrate the treaty and presented it to English statesman William Petty, first Marquess of Lansdowne, who as prime minister had negotiated the end of the Revolutionary War in 1783. Bingham and Petty each had a vested commercial interest in maintaining a peace that would permit transatlantic investment and trade. After completing the work, Stuart was commissioned to paint several replicas.

George Washington, 1732–1799
"Lansdowne" Portrait

———

Gilbert Stuart (1755–1828)
Oil on canvas, 247.6 × 158.7 cm (97½ × 62½ in.), 1796
Acquired as a gift to the nation through the generosity of the Donald W. Reynolds Foundation
NPG.2001.13

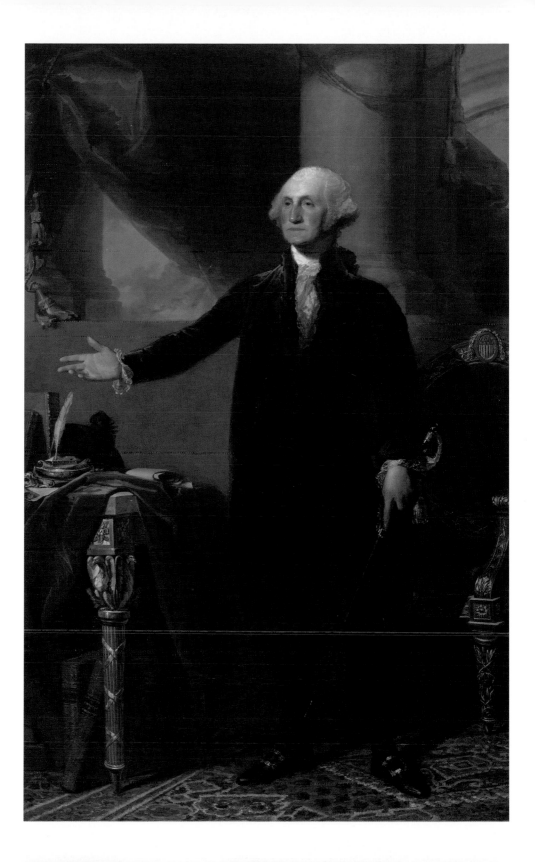

Gilbert Stuart first painted George Washington in 1795, in a work now known only from copies. That painting was so successful that, according to artist Rembrandt Peale, Martha Washington "wished a Portrait for herself." She persuaded her husband to sit again for Stuart "on the express condition that when finished it should be hers." However, Stuart neither finished the painting nor delivered it to the Washingtons. Preferring it to his earlier likeness of the president, he used this work as a model for the numerous copies commissioned by Washington's admirers. After the artist's death, the painting and its pendant (p. 59) were purchased for the Boston Athenaeum, which owned them for more than 150 years. The image served as the basis for the engraving of Washington on the one-dollar bill. John Neal, an early-nineteenth-century writer and art critic, wrote: "Though a better likeness of him were shown to us, we should reject it; for, the only idea that we now have of George Washington, is associated with Stuart's Washington."

George Washington
"Athenaeum" Portrait

————

Gilbert Stuart (1755–1828)
Oil on canvas, 121.9 × 94 cm (48 × 37 in.), 1796
Owned jointly with the Museum of Fine Arts, Boston
NPG.80.115

Gilbert Stuart's unfinished portrait of Martha Washington (1731–1802), which the First Lady commissioned to be a pendant to the portrait of her husband, also remained in the possession of the artist until his death. As early as 1800, just after George Washington's death, Martha asked a friend, Tobias Lear, to press Stuart to deliver both portraits. Lear wrote to Stuart, "With all the persuasive language of which I [am] master, [I] prevail upon you to let Mrs. Washington have the Painting of her dear deceased husband, our late illustrious and beloved Chief." Although Stuart made many copies of the president's portrait over the years, no other likeness of Martha Washington by Stuart is known to exist.

Martha Washington
"Athenaeum" Portrait

———

Gilbert Stuart (1755–1828)
Oil on canvas, 121.9 × 94 cm (48 × 37 in.), 1796
Owned jointly with the Museum of Fine Arts, Boston
NPG.80.116

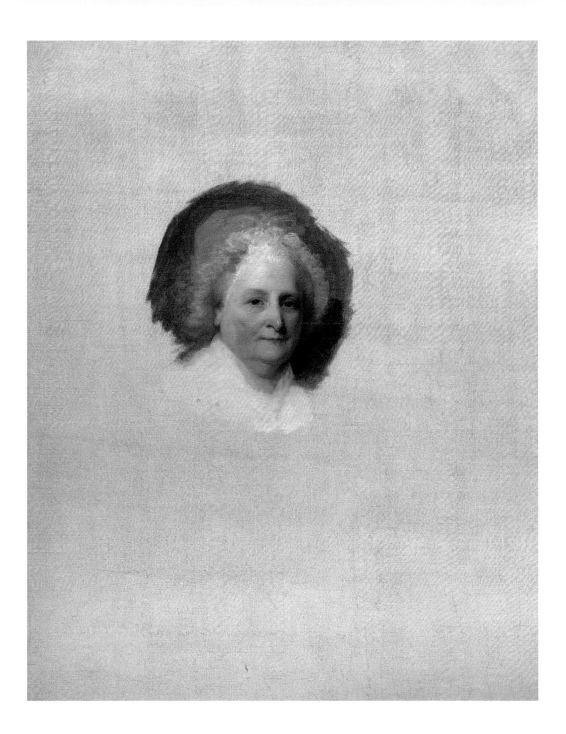

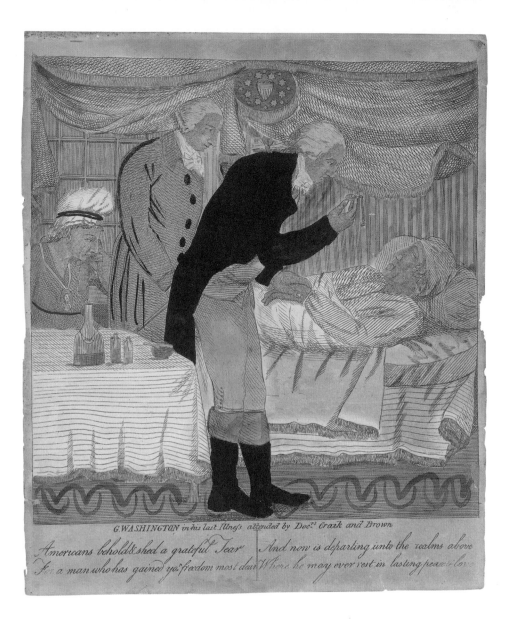

G. WASHINGTON *in his last Illness attended by Doct.s Craik and Brown*

Americans behold & shed a grateful Tear | And now is departing unto the realms above
For a man who has gained y.e freedom most dear | Where he may ever rest in lasting peace & love

Washington in His Last Illness

———

Unidentified artist
Hand-colored etching with watercolor
25.4 × 24.3 cm (10 × 9⁹⁄₁₆ in.), 1800
NPG.85.137

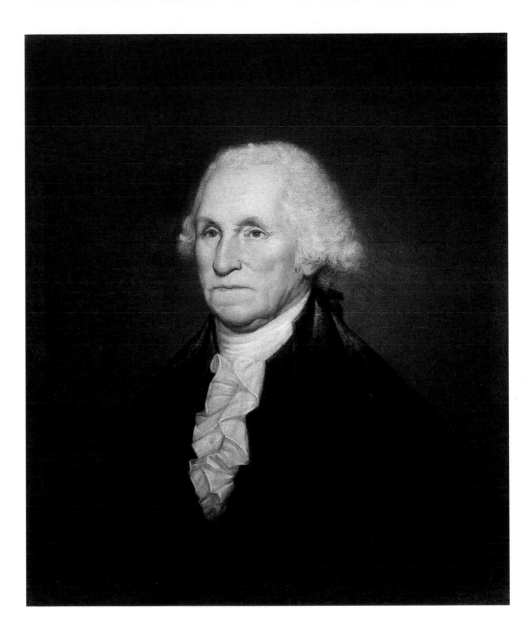

George Washington

————————

Rembrandt Peale (1778–1860)
Oil on canvas, 75.6 × 64.5 cm (29¾ × 25⅜ in.), 1795
Gift of the A. W. Mellon Educational and Charitable Trust
NPG.65.59

In 1784, the much-admired French sculptor Jean-Antoine Houdon agreed to execute a full-length marble statue of George Washington for the Virginia State Capitol in Richmond. The artist traveled to the United States the following year to make a life mask of his subject at Mount Vernon. In addition to serving as an aid in completing the final marble statue, the mask became the basis for several plaster and terra-cotta busts, including this one bearing the sculptor's signature. Houdon transformed the raw copy of Washington's features into a work referencing the sculptures of ancient Greece and Rome, reflecting the neoclassical taste in European and American art at the time. Houdon fashioned the first of these smaller likenesses while still in the United States and presented it to Washington before returning to France. The marble statue took some ten years to complete and still resides in the Virginia State Capitol.

George Washington

———

Jean-Antoine Houdon (1741–1828)
Plaster, 55.9 cm (22 in.) height, c. 1786
Partial gift of Joe L. and Barbara B. Albritton
and Robert H. and Clarice Smith
NPG.78.1

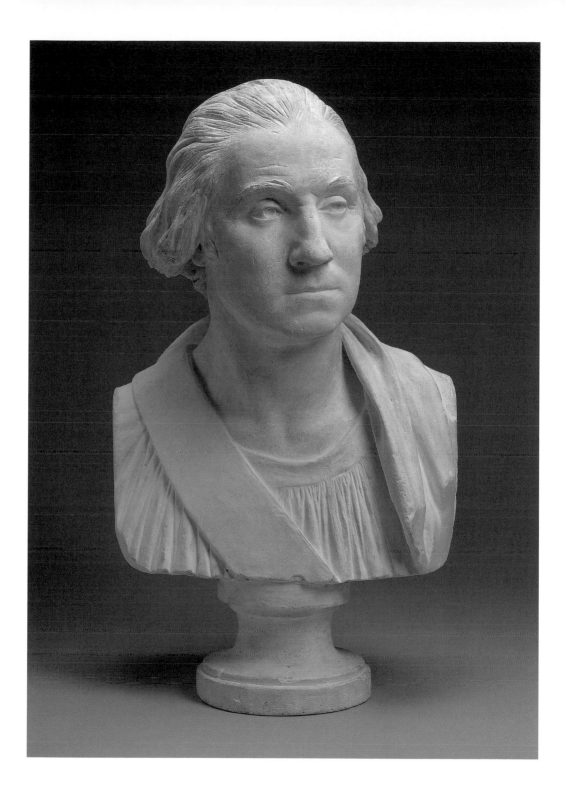

JOHN ADAMS

Of all the Founding Fathers, John Adams was perhaps the most intellectual and accomplished. He helped craft the argument for independence in the Continental Congress; drafted the Massachusetts constitution, which served as a model for the U.S. Constitution; and served on the diplomatic mission that ended the Revolutionary War. George Washington chose him as his vice president, though Adams would complain that his lack of official duties meant that he occupied "the most insignificant office that ever the invention of man contrived." Yet, as has often been the case throughout American history, the ostensibly empty role proved to be a pathway to the presidency. Adams was elected in 1796 after a bitter campaign against Thomas Jefferson as factional politics emerged in the wake of Washington's presidency. His single term in office was filled with political posturing and bickering, both with Jefferson's Democratic-Republican Party and within his own Federalist Party. Foreign affairs weighed heavily upon Adams, especially France's interference with American commerce in its war with Great Britain. He managed to keep the nation at peace, but in so doing he pleased no one, and he left the White House in 1801 largely discredited on all sides.

This portrait was derived from sittings during Adams's vice presidency (1789–97). By that time, John Trumbull had painted two previous likenesses of Adams, including one that was eventually incorporated into his work depicting the signing of the Declaration of Independence, which is now on view in the U.S. Capitol rotunda.

John Adams, 1735–1826

———

John Trumbull (1756–1843)
Oil on canvas, 65.1 × 54.9 cm (25⅝ × 21⅝ in.), 1793
NPG.75.52

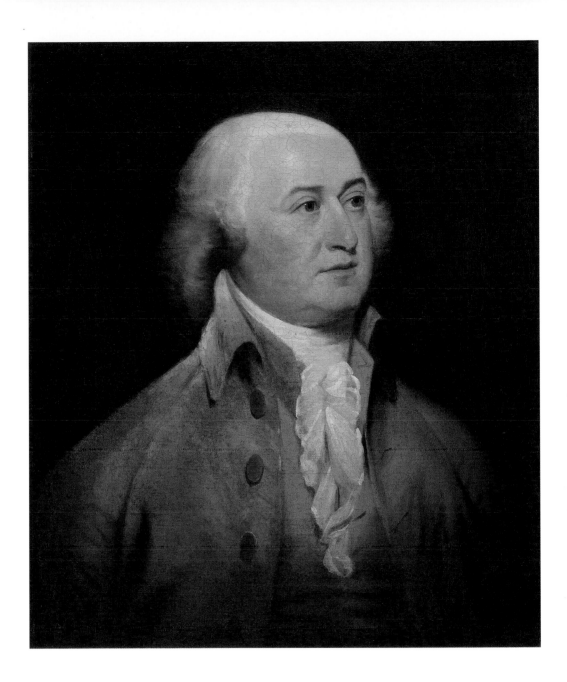

THOMAS JEFFERSON

A scientist, an Enlightment philosopher, and certainly one of the most gifted men and complicated personalities in American history, Thomas Jefferson authored the Declaration of Independence and served his country as a statesman, diplomat, and two-term president. In addition, he was the author of a landmark statute on religious freedom and the founder of the University of Virginia. Throughout his life, Jefferson, a slave owner, wrestled with the contradictions between his philosophical beliefs and the reality of slavery in America. While he considered the possibility of reforming the slave system, he was aware of how dependent U.S. society was on the "peculiar institution": he believed equality for whites depended on a slave economy, which he felt was simply too profitable to be ended. Personally uncomfortable with the day-to-day realities of slave ownership, Jefferson designed his plantation home, Monticello, to include dumbwaiters and hidden passageways so that he would not have to face his slaves.

Recently, historians have argued that it was the very institution of slavery that allowed republican freedom (and democracy) to flourish for white citizens. One of Jefferson's signature accomplishments as president was orchestrating the Louisiana Purchase in 1803, which doubled the size of the United States and established the nation as a continental power. This expansion also ensured that the country would have to continue to grapple with the political effects of a growing slave economy.

Gilbert Stuart made at least three portraits of Jefferson from sittings in 1800 and 1805. This work is probably Stuart's replica of a portrait he created in 1805. After much prompting, the painting was delivered to Jefferson at Monticello in 1821. After the president's death, his grandson Colonel Thomas J. Randolph owned the work and kept it at his estate, Edgehill, for seventy-five years.

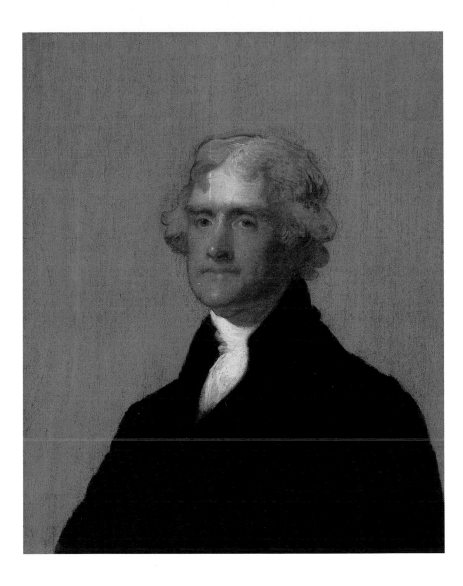

Thomas Jefferson, 1743–1826
"Edgehill" Portrait

———

Gilbert Stuart (1755–1828)
Oil on mahogany panel, 66.4 × 53.3 cm (26⅛ × 21 in.), 1805/1821
Owned jointly with Monticello, Thomas Jefferson Foundation,
Charlottesville, Virginia; gift of the Regents of the Smithsonian
Institution, the Thomas Jefferson Foundation, Incorporated,
and the Enid and Crosby Kemper Foundation
NPG.82.97

JAMES MADISON

James Madison may have been the shortest president at just over five feet, but his true stature derived from his intellect. He coauthored, with Alexander Hamilton and John Jay, *The Federalist Papers* (1787–88), a set of eighty-five essays arguing for the ratification of the Constitution that remains among the greatest works of American political thought. Concerned that the Constitution tilted too far toward interests of the federal government, neglecting the individual, Madison wrote the first ten amendments, known as the Bill of Rights.

As president, Madison tried to maintain U.S. neutrality while war raged in Europe, yet ultimately the United States declared war on Britain over attacks on U.S. shipping and the impressment of American seamen into the royal navy. The ensuing War of 1812 was marked by a series of tactical blunders—culminating in the British capture and burning of Washington, D.C., in 1814—as well as the emergence of notable military heroes, including Andrew Jackson (p. 75) and William Henry Harrison (p. 81). The end of hostilities in 1815 saw the cessation of European interference with the United States, a restored sense of national honor, and a new feeling of American unity. In the aftermath of the "Second American Revolution," as it was sometimes called, Madison's reputation rose and the United States enjoyed a period of peace and prosperity known as the Era of Good Feelings.

James Madison, 1751–1836

———

Chester Harding (1792–1866)
Oil on canvas, 76.2 × 63.5 cm (30 × 25 in.), 1829–30
NPG.68.50

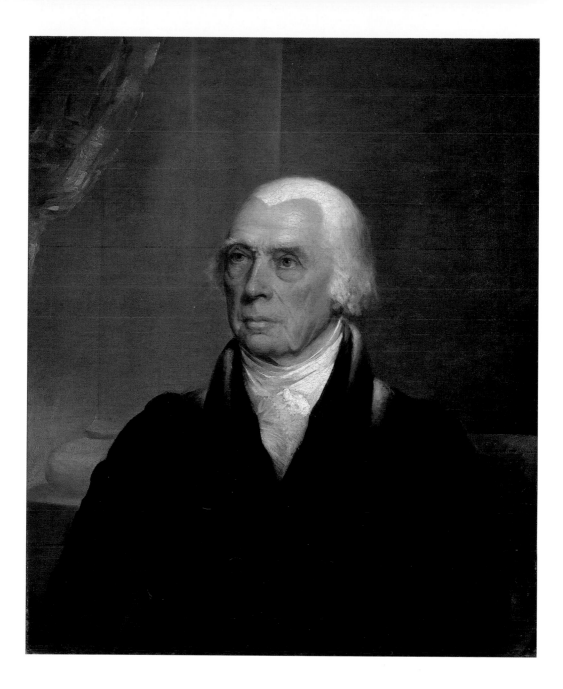

JAMES MONROE

James Monroe continued the Virginia dynasty of Democratic-Republican presidents, which had been interrupted only by the tenure of John Adams. He was one of the last of the Founding Fathers still politically active in 1820, when he stood virtually unopposed in his bid for a second term. His unchallenged candidacy reflected the Era of Good Feelings: the period following the War of 1812, which was marked by a temporary halt in two-party factionalism. The most enduring legacy of his administration, the Monroe Doctrine, articulated opposition to European meddling in the Western Hemisphere and became a keystone of American foreign policy. Another notable event of Monroe's presidency was the admission of Missouri into the Union as a slave state in 1820. Fearful that conflicts over the spread of slavery might destroy the nation, Monroe approved the simultaneous admission of Maine to the Union, maintaining the balance of free and slave states. The Missouri Compromise indicated the desire to defer the ultimate resolution of the slavery issue, although many understood that a reckoning could not be postponed indefinitely.

When Monroe was elected in 1816, the majority of voters did not know what he looked like. Earlier that year, however, his friend John Vanderlyn, who had recently returned from studying art in Paris, painted two portraits of him in Washington, D.C. Monroe gave one to his friend James Madison and kept this one; the image was quickly engraved for public dissemination. With its careful rendering of features, highly finished surface, and clarity of lighting, Vanderlyn's painting exemplifies the French neoclassical style, prevalent at that time.

James Monroe, 1758–1831

———————

John Vanderlyn (1775–1852)
Oil on canvas, 67.3 × 57.2 cm (26½ × 22½ in.), 1816
NPG.70.59

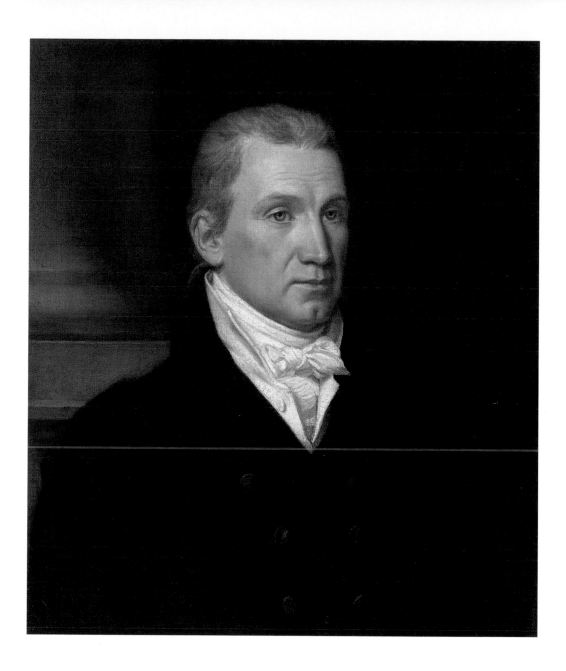

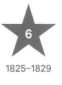

JOHN QUINCY ADAMS

The election of 1824 involved multiple candidates, and after a deadlock in the Electoral College, the House of Representatives chose John Quincy Adams over the popular military hero Andrew Jackson. John Quincy Adams was the son of John Adams (p. 65), and like his father, he bristled with an intelligence that was perhaps a detriment in the rough and tumble of American politics. His qualifications for the presidency were many, including his tenure as James Monroe's secretary of state. Yet his often tactless temperament and refusal to compromise his high ideals put him at odds with the emergent democracy, which gave the populist Jackson the presidency in the 1828 election. In 1830, Adams revived his political career with his election to the House of Representatives, where he would serve until his death. His dedicated and successful struggle to defend the right of antislavery advocates to petition Congress won him many admirers beyond his Massachusetts constituency and is perhaps his proudest legacy today.

Adams was one of the most widely portrayed Americans of his generation, in part because he was interested in the fine arts, especially portraiture. When George Caleb Bingham (who later served as a public official in Missouri) painted his image in 1844, Adams doubted the artist could produce "a strong likeness," yet in the end he was pleasantly surprised.

John Quincy Adams, 1767–1848

George Caleb Bingham (1811–1879)
Oil on canvas, 76.2 × 63.5 cm (30 × 25 in.), c. 1850, after 1844 original
NPG.69.20

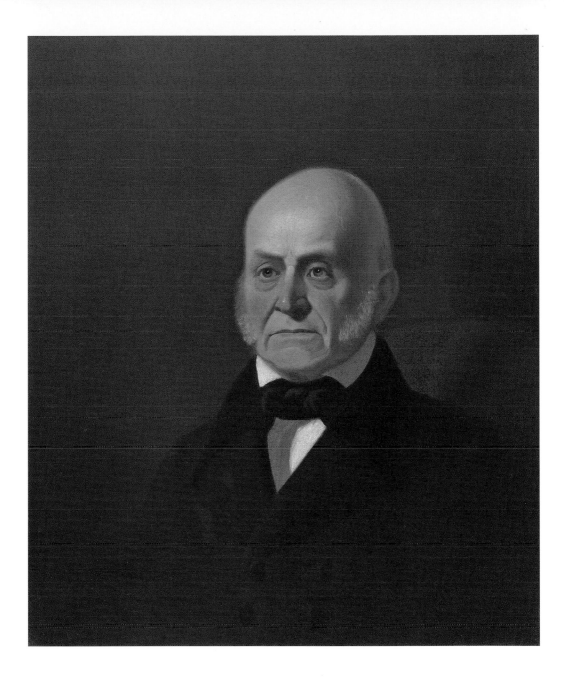

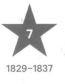

ANDREW JACKSON

The orphaned son of impoverished Scots-Irish immigrants, Andrew Jackson lived a life of struggle and conflict. He was the only president to have been a prisoner of war, and the only one to kill a man in a duel. As a general in the U.S. military, he battled Native Americans and British alike and wrested Florida away from the Spanish. His victory in the Battle of New Orleans at the end of the War of 1812 made him a national hero—and an immediate presidential contender. His presidency would be defined by similar aggression: he signed the Indian Removal Act into law, struck down the Bank of the United States through the power of the veto, and threatened to use military might to preserve the Union when South Carolina tried to undermine the authority of the federal government. Perhaps his most significant contribution to history is his establishment of what became known as Jacksonian Democracy: agrarianism, free-market economics, limited government, Manifest Destiny, and voting rights for all white men, regardless of social class. Once seen entirely as a symbol of the nation's expansive democracy, Jackson is now a controversial figure for his uncompromising nationalism and punitive policies toward Native Americans.

Thomas Sully painted Jackson from life on only two occasions, in 1819 and in 1824, but he made a number of portraits of him. This is the second of Sully's life studies of Jackson. After using the portrait as a basis for replicas, the artist gave the painting to Jackson while he was serving as president. When Jackson left the White House, in 1837, he gave it to his friend Francis Preston Blair Sr., in whose family it remained. This image has become the standard picture of Jackson, and it reveals the animation and freshness of a painting made from a life sitting.

Andrew Jackson, 1767–1845

———

Thomas Sully (1783–1872)
Oil on canvas, 59.1 × 49.5 cm (23¼ × 19½ in.), 1824
Private collection

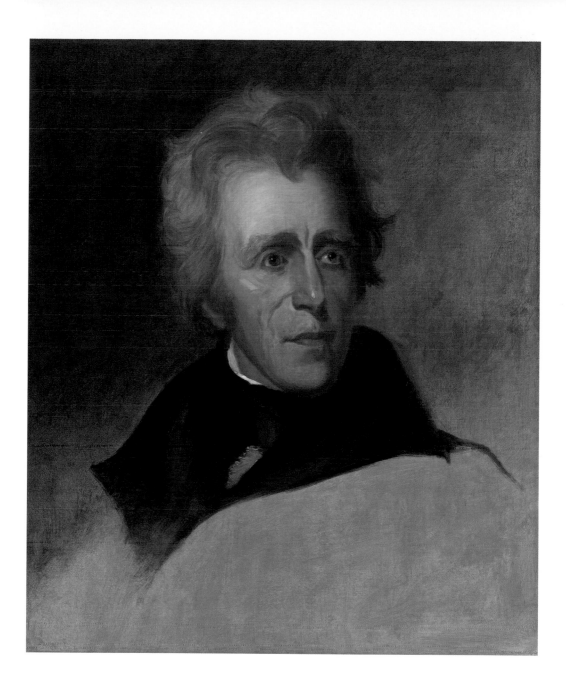

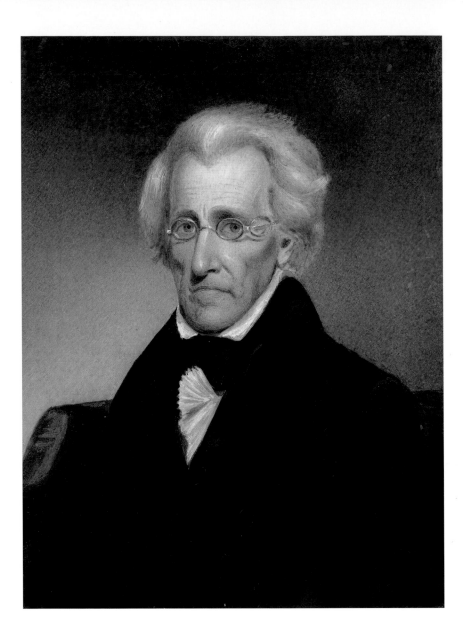

Andrew Jackson

———

James Tooley Jr. (1816–1844), after Edward Dalton Marchant
Watercolor on ivory, 10.8 × 7.9 cm (4¼ × 3⅛ in.), 1840
Gift of Mr. William H. Lively, Mrs. Mary Lively Hoffman, and Dr. Charles J. Lively
NPG.66.43

Andrew Jackson

———

Cast after Clark Mills (1810–1883)
Zinc, 67.3 cm (26½ in.) height (with base), 1855
Gift of Mr. and Mrs. John L. Sanders in memory of William Monroe Geer
NPG.85.8

MARTIN VAN BUREN

Martin Van Buren was the consummate machine politician: clever, strategic, and a master of political patronage. He helped found the Democratic Party, which put Andrew Jackson in the White House, and he succeeded his patron to the presidency after serving as his vice president. However, he had the misfortune to be president during the Panic of 1837—an unprecedented economic crisis that brought about a five-year economic depression and earned him the unflattering epithet "Martin Van Ruin." (Today many scholars believe that the panic was actually caused by forces beyond Van Buren's control, including the policies of his predecessor, Jackson.)

Van Buren also had to deal with the growing problem of slavery, attempting to navigate between those who supported the spread of slave labor and those who called for its outright abolition. After losing his reelection bid in 1840 by a significant margin, he remained a presence on the national political scene and made another unsuccessful bid for president with the antislavery Free-Soil Party in 1848. Van Buren seems to have grown disillusioned with the presidency, having once stated that "the two happiest days of my life were those of my entrance upon the office and my surrender of it."

Martin Van Buren, 1782–1862

George Peter Alexander Healy (1813–1894)
Oil on canvas, 158.8 × 120.7 cm (62½ × 47½ in.), 1858 (signed 1864)
Lent by the White House, Washington, D.C.

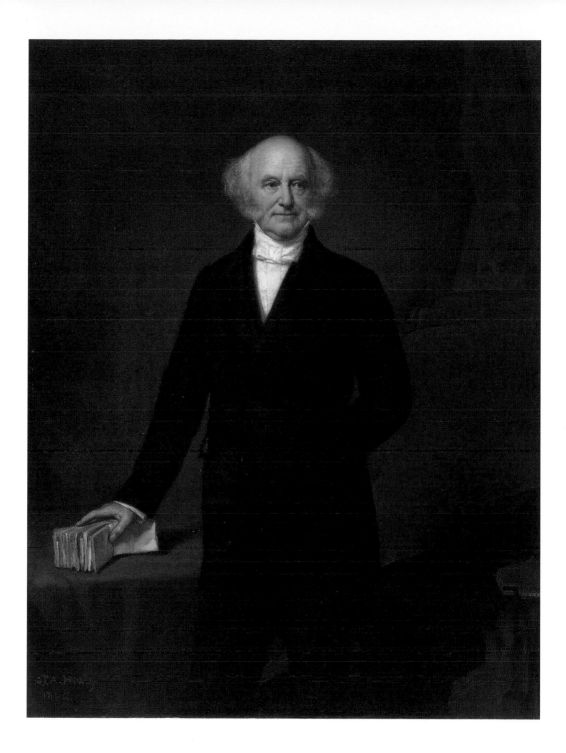

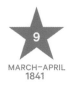

WILLIAM HENRY HARRISON

The candidacy of William Henry Harrison indicated that American politics were moving in a more populist direction as the country and the electorate expanded. A two-term congressman and former territorial governor, Harrison had no noteworthy political abilities, but for the Whig Party in 1840, desperate to counter the Jacksonians, he was the perfect figurehead: a military hero in the War of 1812 and a frontier fighter of Native Americans. Harrison's supporters celebrated his military prowess and combined it with homespun frontier imagery, such as log cabins and hard cider, in a presidential campaign that was unprecedented for its carnival-like hoopla. While discussions of real issues were rare, the ballyhoo of the race proved sufficient in itself to win Harrison the presidency.

Jubilance over his victory, however, was short-lived. On April 4, 1841, exactly one month after delivering a very long inaugural address in extremely harsh weather, Harrison became the first president to die in office. Until recently, the cause of his death was thought to have been pneumonia, but new evidence suggests that he may, in fact, have suffered from enteric fever and septic shock.

William Henry Harrison, 1773–1841

———

Albert Gallatin Hoit (1809–1856)
Oil on canvas, 76.2 × 63.5 cm (30 × 25 in.), 1840
NPG.67.5

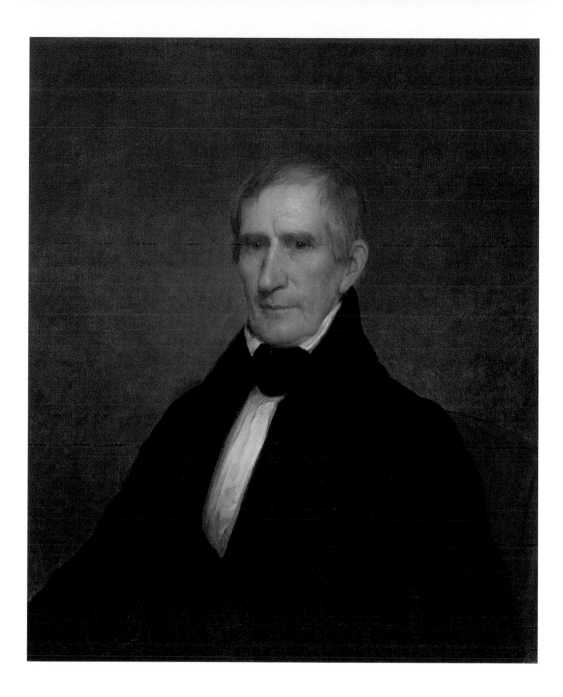

JOHN TYLER

John Tyler was not elected to serve as president, but after Harrison's untimely death, he became the first vice president to ascend to the office. For this reason, many referred to President Tyler as "His Accidency," and his authority was frequently questioned. In September 1841, his entire cabinet resigned in disgust after quarreling with him over federal banking policy. Soon afterward, Tyler was expelled from the Whig Party (which would later mount an unsuccessful bid to impeach him). Tyler's efforts to appoint like-minded justices to the Supreme Court were met with fierce opposition in the House of Representatives and the Senate, and he was the first president to have Congress override one of his vetoes.

After his term ended, Tyler became a proponent of Southern secession and was even elected to the Confederate House of Representatives. His death in 1862 went unrecognized in Washington, D.C., but in the South, he was mourned as a hero—the only president to be eulogized and buried under a Confederate flag.

In 1857, Congress commissioned George Peter Alexander Healy to create a series of portraits of the presidents for the White House. In February 1859, Healy traveled to Tyler's home in Virginia, where he was able to paint the former president's features from life again. This is a smaller replica of Tyler's official White house portrait, and the place and date of the sitting are inscribed on the back of this canvas.

John Tyler, 1790–1862

George Peter Alexander Healy (1813–1894)
Oil on canvas, 91.8 × 74 cm (36⅛ × 29⅛ in.), 1859
Gift of Friends of the National Institute
NPG.70.23

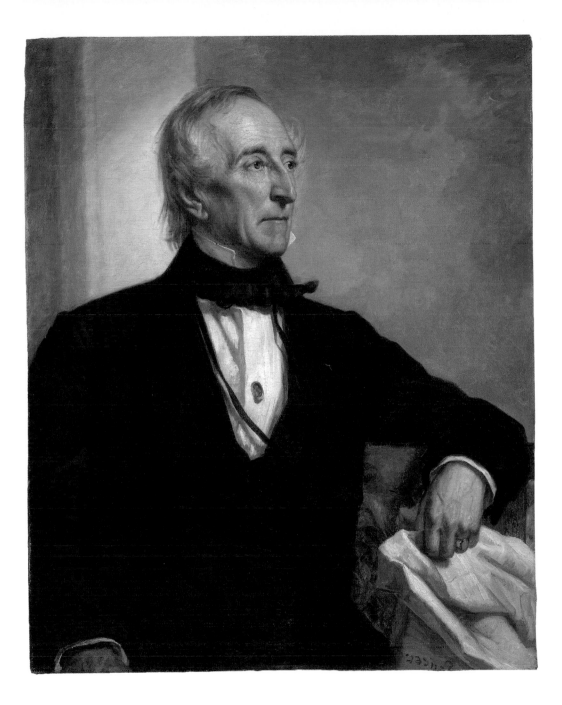

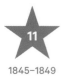

JAMES K. POLK

The life and career of James K. Polk reflect the country's westward shift in the nineteenth century. As a child, his path followed the frontier as he moved from his birthplace in North Carolina to Tennessee. After graduating from the University of North Carolina, he returned to Tennessee to begin his career as a lawyer and serve in the state legislature. Polk, who found a political mentor in family friend and fellow Tennessean Andrew Jackson, supported Jackson's policies in Congress, where he served as Speaker of the House from 1835 to 1839. Polk favored western expansion, and as president, he acquired more than a million square miles of territory for the United States, in part by fomenting the Mexican-American War (1846–48). Driven and determined, Polk took office with a limited agenda, accomplished all of it, and left office, as he had planned, after a single term. Although little recognized today, Polk was one of the most consequential presidents in American history, as the vast expanse of territory acquired during his administration opened up the question of the future of slavery and fueled the conflict that led to the Civil War.

James K. Polk, 1795–1849

—————

George Peter Alexander Healy (1813–1894)
Oil on canvas, 77.5 × 64.8 cm (30½ × 25½ in.), 1846
The Corcoran Gallery of Art, Washington, D.C.
Museum Purchase, Gallery Fund

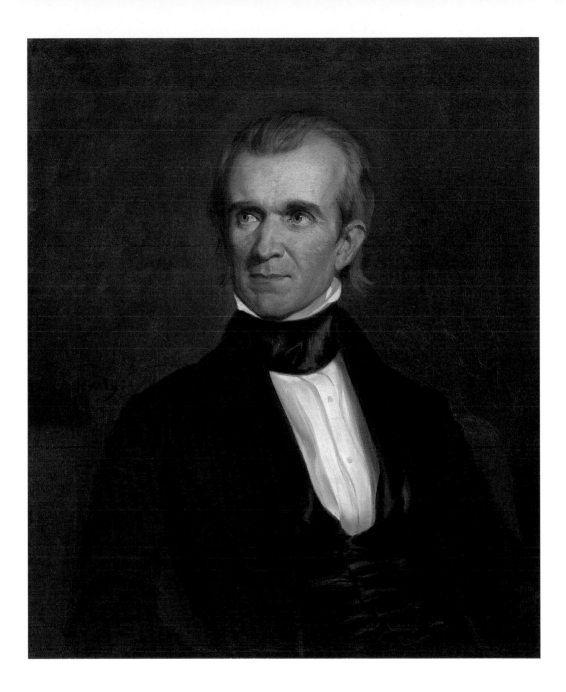

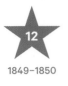

ZACHARY TAYLOR

The presidency of Zachary Taylor exemplifies the American tendency to reward successful military commanders with the White House. Despite being avowedly apolitical (or perhaps because of it), Taylor was swept into the White House on a wave of popularity resulting from his victories in the Mexican-American War. He began his presidency with promises of bringing harmony to the Union, yet within a year of taking office, the ongoing debate over slavery—one triggered in part by his own military success against Mexico—brought the nation closer to a sectional divide. Under his administration, Congress struggled to resolve the manifold political issues related to slavery, from the status of slavery in the territories and the District of Columbia to the Fugitive Slave Act. Taylor was in favor of keeping slavery out of the new territories of California and New Mexico. His best efforts were ended by his sudden death less than two years into his presidency, and a modified Compromise of 1850 was eventually negotiated.

In this election-year portrait, Taylor is presented as a sedate and uncharacteristically well-groomed figure. "Old Rough and Ready," as Taylor's soldiers knew him, commonly dressed "entirely for comfort," wrote one of his lieutenants, Ulysses S. Grant (p. 103).

Zachary Taylor, 1784–1850

—————

Attributed to James Reid Lambdin (1807–1889)
Oil on canvas, 76.8 × 63.8 cm (30¼ × 25⅛ in.), 1848
Gift of Barry Bingham Sr.
NPG.76.7

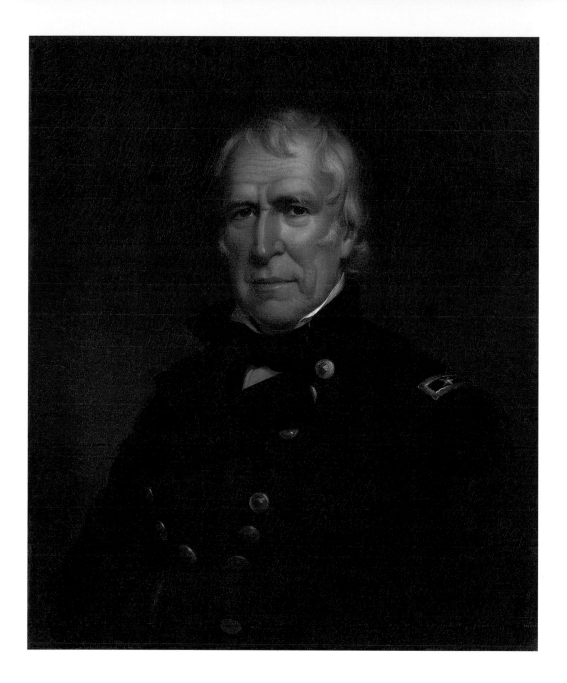

MILLARD FILLMORE

The arc of Millard Fillmore's political career demonstrates how the issue of slavery destroyed the national party system during the late antebellum period. A Whig from upstate New York who took a moderate course in all things, Fillmore found slavery repugnant but did not think the federal government should interfere in the South's "peculiar institution." While serving as a congressman in 1848, Fillmore was picked as Zachary Taylor's running mate because he excited few strong opinions. He became president after Taylor's death and attempted to complete work on the omnibus Compromise of 1850, which dealt with slavery in the territories and was begun under his predecessor. Fillmore ultimately signed the legislation, which aimed to balance various interests in an effort to head off the impending crisis over slavery. While the legislation abolished slavery in Washington, D.C., and admitted California to the Union as a free state, its inclusion of the Fugitive Slave Act—which ordered escaped slaves to be returned to their owners—ultimately led to the breakup of the Whig Party and ended Fillmore's national career. With the demise of his party, Fillmore refused to become a Republican and instead became a supporter of the anti-immigration American ("Know-Nothing") Party.

Millard Fillmore, 1800–1874

———

James Reid Lambdin (1807–1889)
Oil on canvas, 74.9 × 62.2 cm (29½ × 24½ in.), c. 1858
Lent by Mr. and Mrs. Robert Fillmore Norfleet Jr.
in memory of R. Fillmore and Elizabeth C. Norfleet
and in honor of our children and grandchildren

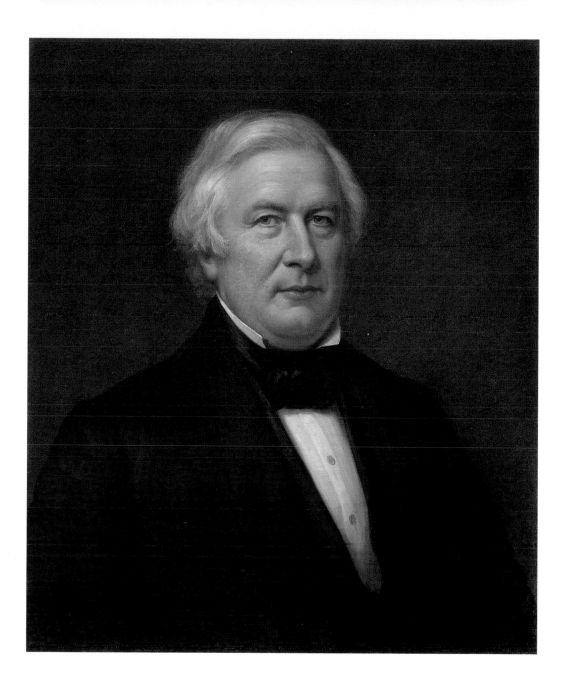

FRANKLIN PIERCE

"What luck Frank has," remarked Nathaniel Hawthorne when he began writing a campaign biography of his lifelong friend Franklin Pierce, the 1852 Democratic candidate for president. Pierce had led an easy life, coasting effortlessly through elections to state offices in New Hampshire and to Congress, and rising from the rank of private to brigadier general in the Mexican-American War without firing a shot. Handsome, affable, and dedicated to compromise, he was elected president at the age of forty-eight. Once he was in the White House, however, Pierce's luck ran out. When fighting erupted in Kansas between pro- and antislavery factions, Pierce, a Northerner with Southern sympathies, was unwilling to antagonize his Southern friends or to use the authority of his office to intervene. Thus his administration, which had begun so hopefully, with promises to follow the Compromise of 1850, ended amid a series of violent political confrontations, collectively known as "Bleeding Kansas," that foreshadowed the Civil War.

Franklin Pierce, 1804–1869

———

George Peter Alexander Healy (1813–1894)
Oil on canvas, 76.5 × 64.1 cm (30⅛ × 25¼ in.), 1853
Gift of the A. W. Mellon Educational and Charitable Trust
NPG.65.49

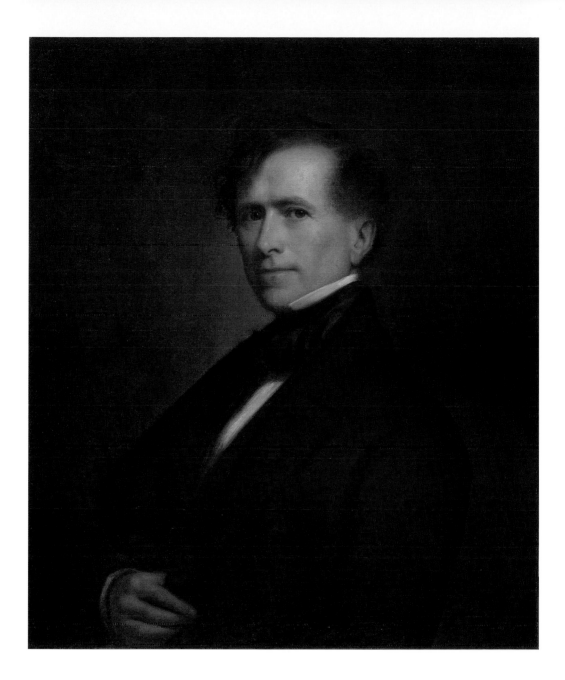

JAMES BUCHANAN

James Buchanan came to the presidency hoping to quiet sectional tensions between pro- and antislavery states, yet animosities only deepened under his ineffectual leadership. Two days after his inauguration, the Supreme Court ruled in the *Dred Scott* case that, since the Constitution protected slave property, Congress could not prohibit slavery from any territory. Buchanan's already weak political position was then further undermined by an economic depression. He was not successful in his efforts to expand American borders into Alaska, Cuba, or Mexico, and a series of scandals wracked his administration, which was one of the most corrupt in American history. By the end of Buchanan's disastrous presidency, anger between the North and the South waxed ever stronger, and the long-feared specter of civil war was turning into a reality. During the long "Secession Winter," which followed Lincoln's election in 1860, Buchanan did nothing to prevent the first Southern states from seceding, and his haplessness has cemented his reputation as one of the least effective U.S. presidents.

James Buchanan, 1791–1868

———————

George Peter Alexander Healy (1813–1894)
Oil on canvas, 157.5 × 119.4 cm (62 × 47 in.), 1859
Gift of the A. W. Mellon Educational and Charitable Trust
NPG.65.48

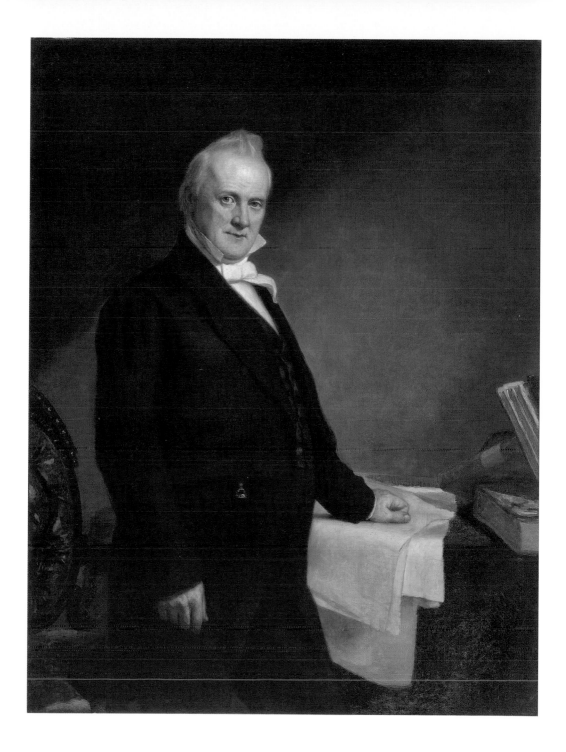

16

1861–1865

ABRAHAM LINCOLN

Like Andrew Jackson before him (p. 75), Abraham Lincoln was a frontiersman who came from less than auspicious beginnings: both men were born in backcountry log cabins, and both went on to become self-educated frontier lawyers. Both men also possessed a firm belief in the Union and were willing to defend it no matter what controversy followed. Yet Lincoln's responsibilities were far more demanding than Jackson's. As he said when he left Illinois to be inaugurated, he was faced with the greatest task since George Washington: not to establish the Union, but to preserve it.

Lincoln had hoped to avoid war, but it became inevitable given that the issue of slavery had divided the nation into two separate societies. He initially framed the conflict as a Constitutional crisis over secession, without reference to slavery, but as the war intensified beyond anyone's expectations—it was the first truly modern war, with casualties to match—Lincoln's aims evolved to include reunification based on the abolition of slavery. In 1863, he issued the Emancipation Proclamation, and in the Gettysburg Address, in November of that year, he explicitly argued for a "new birth of freedom" to restore the Union and reestablish American democracy. When the long and devastating conflict finally had ended, the president proposed a program of Southern reconstruction that was not punitive but did require African American civil rights. Yet he was assassinated by John Wilkes Booth before he could implement his program.

George Peter Alexander Healy painted a life portrait of Lincoln in 1860, but he had to rely on other portraits to create this image, one of four he created after Lincoln's death. All four are derived from the likeness Healy composed for an 1868 group portrait, *The Peacemakers*, which documents a spring 1865 shipboard meeting at City Point, Virginia, among Lincoln, Generals William T. Sherman and Ulysses S. Grant (p. 103), and Rear Admiral David D. Porter, at which they discussed strategy concerning the end of the Civil War.

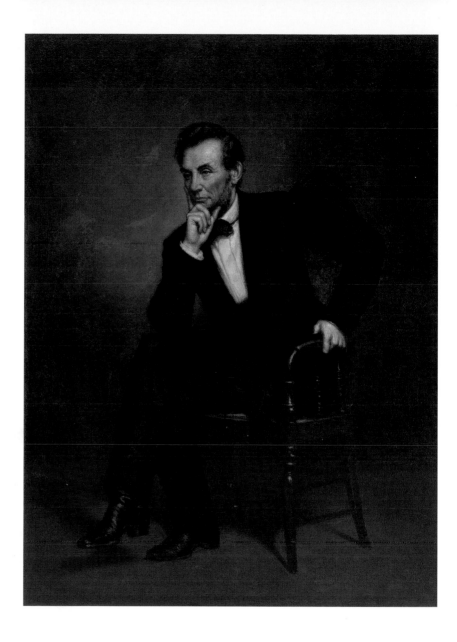

Abraham Lincoln, 1809–1865

————

George Peter Alexander Healy (1813–1894)
Oil on canvas, 188 × 137 cm (74 × 53¹⁵⁄₁₆ in.), 1887
Gift of the A. W. Mellon Educational and Charitable Trust
NPG.65.50

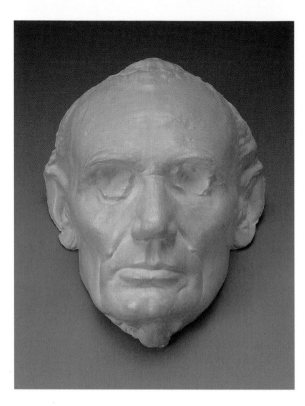

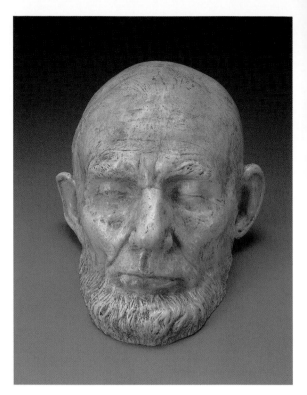

Life mask of Abraham Lincoln

————

After Leonard Wells Volk (1828–1895)
Plaster, 14.6 cm (5¾ in.) height, 1917 cast, after 1860 original
NPG.71.24

Life mask of Abraham Lincoln

————

After Clark Mills (1810–1883)
Plaster, 17.1 cm (6¾ in.) height, c. 1917 cast, after 1865 original
NPG.71.26

Casts of Abraham Lincoln's hands

———

After Leonard Wells Volk (1828–1895)
Plaster, left hand (pictured at right): 7.6 cm (3 in.);
right hand (pictured at left): 8.6 cm (3½ in.) height
c. 1917, after 1860 original
S/NPG.71.6

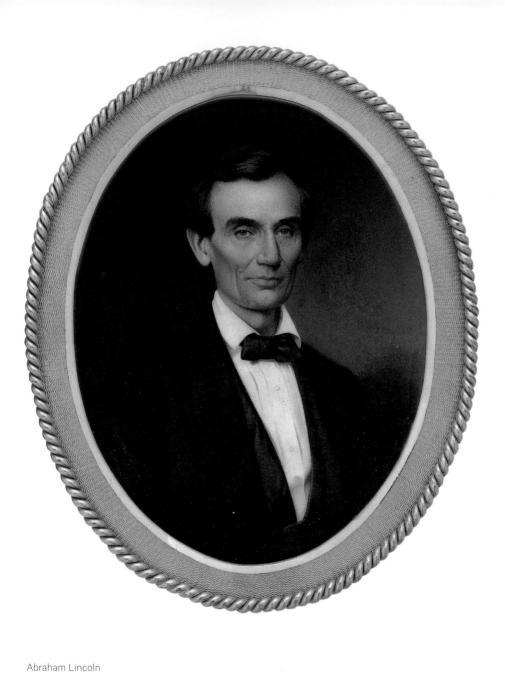

Abraham Lincoln

John Henry Brown (1818–1891)
Watercolor on ivory, 14 × 11.4 cm (5½ × 4½ in.), 1860
Conserved with funds from the Smithsonian Women's Committee
NPG.75.11

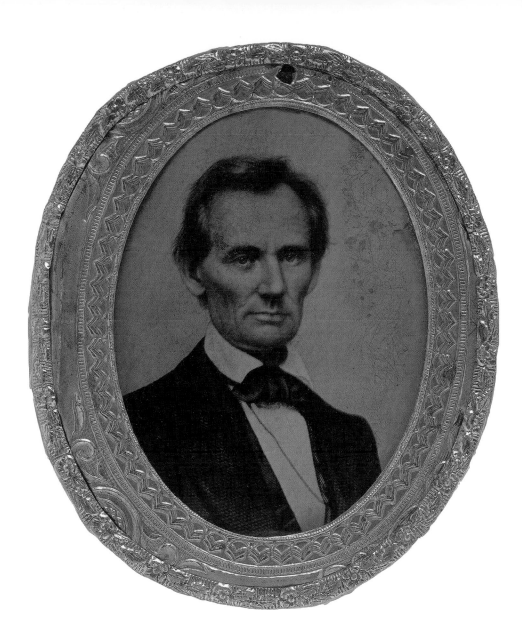

Abraham Lincoln

George Clark (active 1853–1860), after Mathew Brady
Ambrotype campaign pin, 4.8 × 3.5 cm (1⅞ × 1⅜ in.) image, 1860
NPG.2007.194

ANDREW JOHNSON

A onetime tailor whose wife had taught him to read, Andrew Johnson had a gift for public speaking that launched him on a successful political career. In 1864, Abraham Lincoln, in a gesture of unity, chose Johnson—a Southern Democrat from Tennessee but a staunch defender of the Union—as his running mate to help hold the border states. When Johnson succeeded to the presidency after Lincoln's assassination in April 1865, it became evident that his view of Reconstruction, which would return power to the white Southern planters and allow the former Confederate states to deprive freed slaves of their rights, clashed not only with Lincoln's vision but also with the Republican majority in Congress. The resulting conflict led to his impeachment, after which he avoided conviction by only one vote.

This signed but undated painting by Washington Bogart Cooper, a noted Tennessee portraitist, was likely completed during Johnson's presidency.

Andrew Johnson, 1808–1875

———

Washington Bogart Cooper (1802–1889)
Oil on canvas, 92.1 × 74.3 cm (36¼ × 29¼ in.), after 1866
NPG.86.213

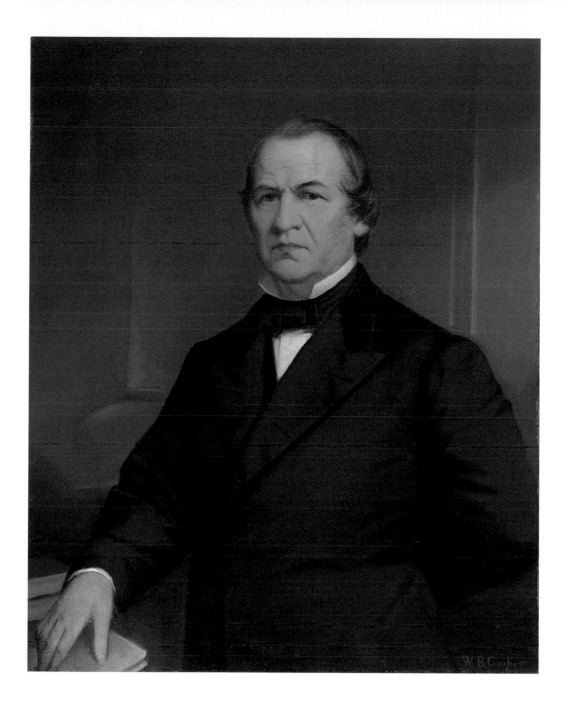

ULYSSES S. GRANT

Ulysses S. Grant's life was a series of paradoxes—many of them tragic. He was a West Point graduate who had no real ambition to be in the military: he wanted to be a teacher. Nonetheless, he served with distinction in the Mexican-American War before growing disillusioned with life in the peacetime army, resigning as a captain. Thereafter he scrambled to make a living and seemed to be on the verge of total failure when the Civil War broke out. Given a command in the Midwest, he displayed qualities of leadership and tenacity that had previously gone undetected. Scoring several notable victories, culminating in the Siege of Vicksburg (1863), Grant was brought east by Lincoln to command all the Union armies. His ferocious, unrelenting campaign against Lee, in 1864–65, finally won the war for the North.

A widely celebrated national hero, Grant inevitably was elected president and served two terms. Unfortunately, the powers he had displayed in the army abandoned him in the White House. Aside from his slogan, "Let Us Have Peace," he was unable to manage the politics of Reconstruction, and his hands-off attitude toward his administration spawned an outbreak of federal corruption. Bankrupted after his presidency, Grant wrote his *Memoirs* against the literal deadline of a fatal cancer diagnosis. Although he died before the book was published, it was a commercial and literary success.

Grant posed for this portrait shortly after he returned from a triumphant world tour following his presidency. The largely self-taught Thomas Le Clear painted two versions. Grant originally owned this one, while a second, larger version entered the White House collection.

Ulysses S. Grant, 1822–1885

———

Thomas Le Clear (1818–1882)
Oil on canvas, 136.5 × 80.6 cm (53¾ × 31¾ in.), c. 1880
Gift of Mrs. Ulysses S. Grant Jr.
NPG.70.16

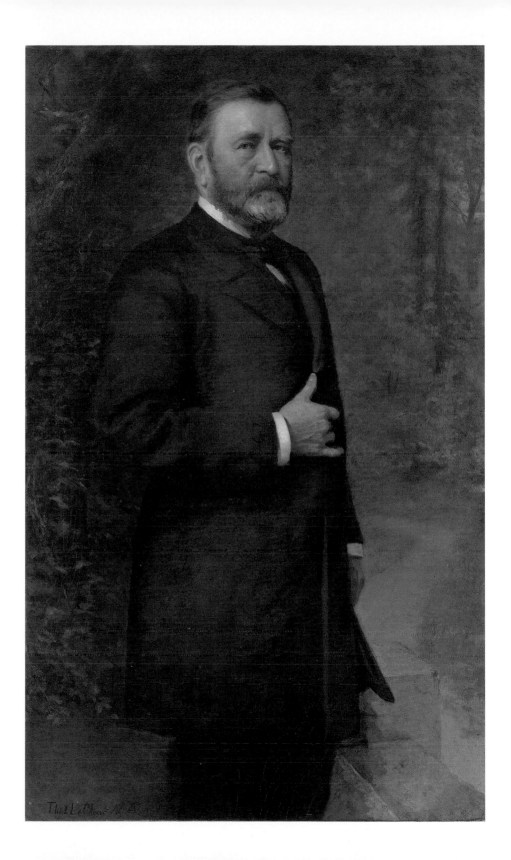

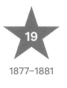

RUTHERFORD B. HAYES

Although Republican candidate Rutherford B. Hayes received fewer popular votes than Democrat Samuel Tilden did in the 1876 general election, Hayes was awarded the presidency after the two major parties struck a bargain. (As a result, opponents later dubbed Hayes "His Fraudulency.") In return for the necessary electoral votes, Hayes withdrew federal troops from the South, thus ending Reconstruction and the federal commitment to African American civil rights. His presidency would be characterized by similar compromises and moderation.

A Civil War veteran who had attained the rank of general, Hayes used military force to put down the Great Railroad Strike of 1877 but privately expressed reservations about his decision. He initiated some mild reforms of the civil service system and tried to promote the cultural assimilation of Native Americans through the education system. He also attempted to prevent inflation by vetoing a bill that sought to reinstate the minting of silver coins. Congress, however, overrode his veto. At the end of his single term, Hayes chose not to run again and retired to Ohio.

Rutherford B. Hayes, 1822–1893

Eliphalet Frazer Andrews (1835–1915)
Oil on canvas, 77.2 × 64.1 cm (30⅜ × 25¼ in.), 1881
Corcoran Gallery of Art, Washington, D.C.
Museum Purchase, Gallery Fund

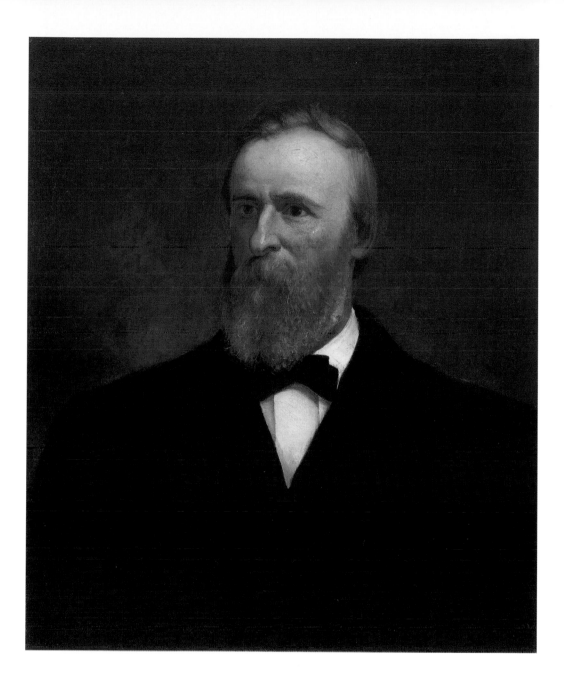

JAMES GARFIELD

James Garfield became president during a period when the Republican Party was split between two rival wings: the Stalwarts, who supported a program of nepotistic patronage (the "spoils" system), and the Half-Breeds, who opposed such a system. He tried to unite the party by appointing members of both factions to important positions within his administration while staying true to his own reformist sympathies. Like Rutherford B. Hayes before him (p. 105), Garfield started to implement some modest changes aimed at curbing corruption and nepotism in the civil service, focusing mainly on the postal system and the New York Customs House. While these policies had little immediate effect, they set the stage for future reforms. Ultimately, Garfield was unable to accomplish much; just six months into his term, he was shot and killed by Charles Guiteau, a deranged office-seeker and self-proclaimed Stalwart.

James Garfield, 1831–1881

———

Ole Peter Hansen Balling (1823–1906)
Oil on canvas, 61 × 50.8 cm (24 × 20 in.), 1881
Gift of the International Business Machines Corporation
NPG.65.25

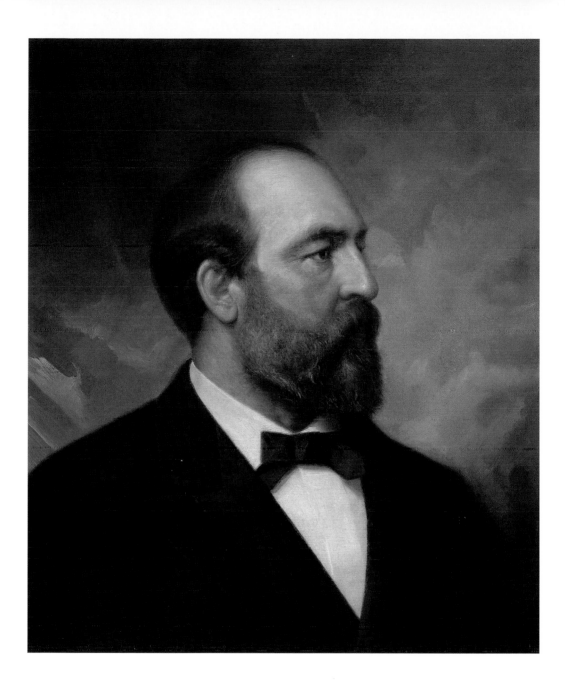

CHESTER A. ARTHUR

When James Garfield (p. 107) was assassinated, he was succeeded by his vice president, Chester A. Arthur. A New York City machine politician and supporter of the spoils system, Arthur in the past had locked horns with Rutherford B. Hayes (p. 105) over the matter of patronage. But in office, Arthur surprised even his harshest critics by continuing his predecessor's battles against corruption in the postal system and the New York Customs Service. By 1884, more than half of all Post Office workers and three-quarters of customs officials were hired based upon competence rather than favoritism. Arthur also signed into law the Pendleton Civil Service Reform Act, which required aspiring bureaucrats to complete merit-based examinations. To ensure that this new act would be enforced, he also appointed a number of reform-minded administrators. In the words of one contemporary, "No man ever entered the presidency so profoundly and widely distrusted" or left it "more generally respected, alike by political friend and foe."

Chester A. Arthur, 1829–1886

———

Ole Peter Hansen Balling (1823–1906)
Oil on canvas, 61.3 × 51.1 cm (24⅛ × 20⅛ in.), 1881
Gift of Mrs. Harry Newton Blue
NPG.67.62

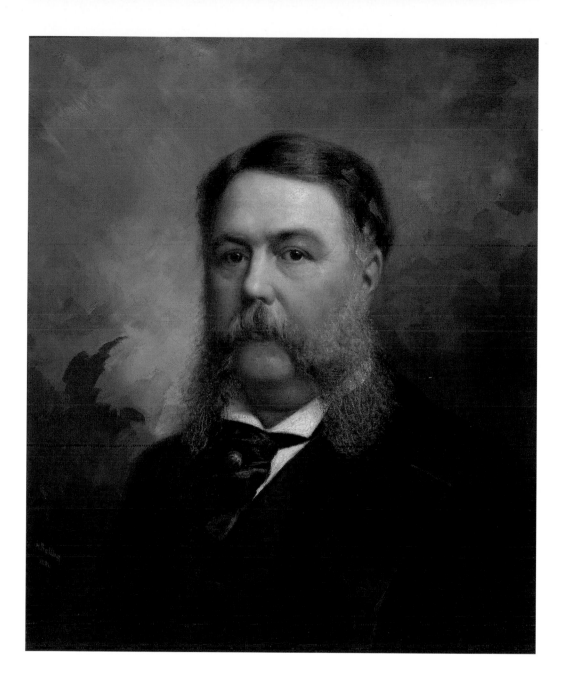

GROVER CLEVELAND

Grover Cleveland was the only president to serve two nonconsecutive terms. Honest and hardworking, he believed in a hands-off government and vetoed more legislation than any previous president, earning him the nickname "Old Veto." Cleveland refused to favor individual groups, vetoing, for instance, what he thought were unnecessary pension bills for Civil War veterans. Ousted from office in 1889 by Benjamin Harrison (p. 113), he returned to the White House four years later. A severe economic depression—the Panic of 1893—plagued his second term. Unable to restore the nation's economy, he was forced to use federal troops to suppress labor unrest. Cleveland failed to win a third nomination.

Swedish artist Anders Zorn created many likenesses of statesmen and society figures during his multiple trips to the United States. He painted this portrait in 1899, two years after the end of Cleveland's second term. The sittings took place at Cleveland's estate in Princeton, New Jersey, where the artist and subject bantered happily for several days. At the same time, Zorn made a stunning portrait of Frances Folsom Cleveland, the president's popular young wife. The president was pleased with his own portrait, declaring, "As for my ugly mug, I think the artist has 'struck it off' in great shape."

Grover Cleveland, 1837–1908

———

Anders Zorn (1860–1920)
Oil on canvas, 121.8 × 91.4 cm (47$\frac{15}{16}$ × 36 in.), 1899
Gift of the Reverend Thomas G. Cleveland
NPG.77.229

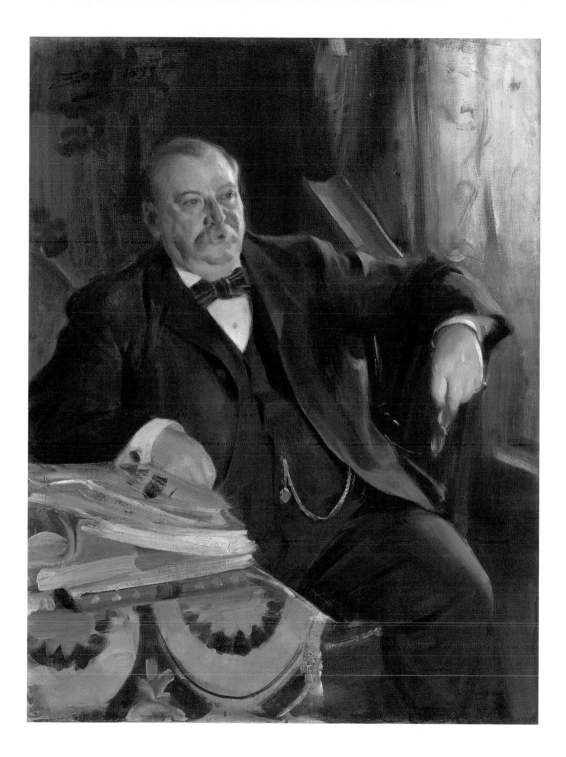

BENJAMIN HARRISON

Although the United States is a popular democracy, the American electorate has shown a predisposition for political dynasties, with families such as the Adamses, the Kennedys, and the Bushes. Benjamin Harrison came from a political family and was the grandson of the ninth president, William Henry Harrison. Like his grandfather, Benjamin Harrison had a political career that was aided by military service. During the Civil War, Harrison, who had been an Indianapolis lawyer, created the Seventieth Indiana Regiment, which was instrumental in the capture of Atlanta. Ending his military career in 1865 as a brigadier general, he became involved in Indiana politics and was elected to the Senate in 1881. A compromise nominee of the Republican Party in 1888, he defeated incumbent Democrat Grover Cleveland (p. 111) in the general election. Benjamin Harrison's presidency was dominated by economic issues, especially the tariff, and the growth of government spending on his watch caused a backlash. Harrison was defeated in the 1892 election by Cleveland, who ran a second time.

Benjamin Harrison, 1833–1901

———

Theodore Clement Steele (1847–1926)
Oil on canvas, 101.9 × 127.6 cm (40⅛ × 50¼ in.), 1900
Lent by Harrison Residence Hall, Purdue University
West Lafayette, Indiana

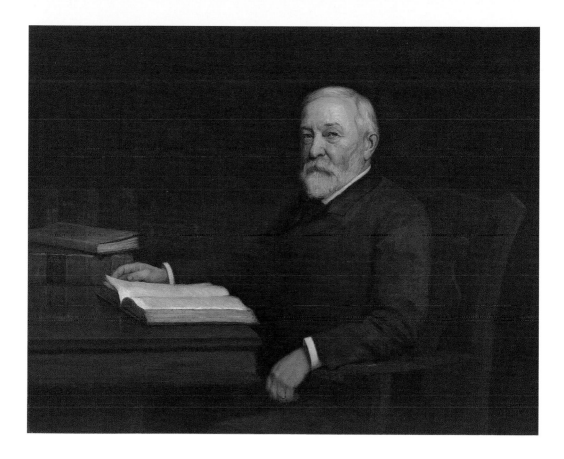

WILLIAM McKINLEY

Like many presidents elected during the post–Civil War era, William McKinley had served in the Union army, rising from private to major. He then progressed from U.S. representative to governor of Ohio and then to the presidency. In the 1896 election, he defeated the populist Democrat William Jennings Bryan in a landslide election, cementing the Republican Party's conservative pro-business platform. In foreign policy, the war with Spain (1898) marked the United States' emergence as a budding world power; by the conflict's end, America had gained the territories of Guam, the Philippines, and Puerto Rico. On a personal level, McKinley is remembered for his patience, kindness, and dedication to his wife, Ida, who struggled with epilepsy and the deaths of their infant daughters. After his reelection in 1900, McKinley was assassinated by an anarchist at the 1901 Pan-American Exposition in Buffalo, New York, and the killing underscored the continuing social and political unrest of the tumultuous 1890s.

William McKinley, 1843–1901

———

August Benziger (1867–1955)
Oil on canvas, 149 × 99 cm (58¹¹⁄₁₆ × 39 in.), 1897
Gift of Miss Marieli Benziger
NPG.69.34

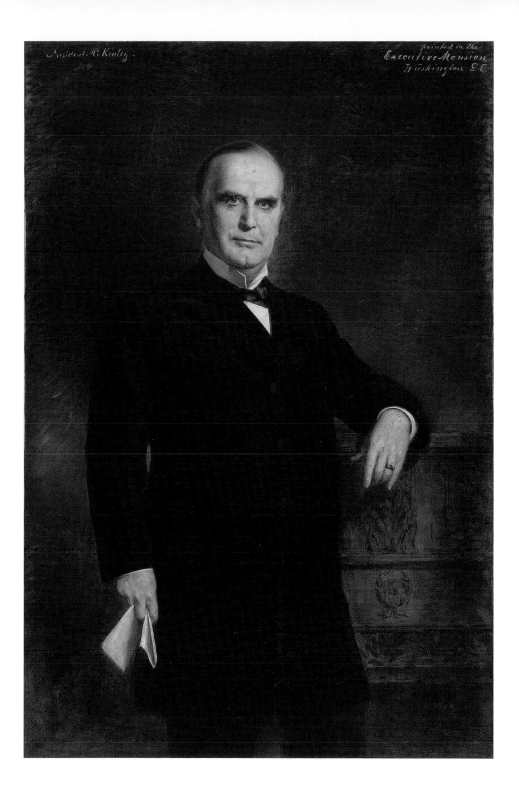

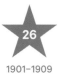

THEODORE ROOSEVELT

An outsize personality who preached the benefits of the "strenuous life" while also being among the most learned of presidents (he wrote more than thirty books), Theodore Roosevelt gained national prominence as a civil service reformer, a hero of the Spanish-American War, and a proactive governor of New York. Assuming the presidency after William McKinley (p. 115) was assassinated in 1901, Roosevelt initiated one of American history's most reform-oriented presidencies. His accomplishments included implementing landmark efforts to conserve the nation's disappearing natural heritage, instituting some of the first significant curbs on the excesses of big business, and building the Panama Canal. Despite holding progressive views on labor and consumer issues, Roosevelt maintained conservative views on a number of social issues. He was convinced that a declining birthrate among old-stock Americans threatened the nation as a whole and therefore opposed immigration, birth control, and the redefinition of women's roles. Roosevelt was a fascinating bundle of contradictions, above all in his role as a patrician who realized that unless essential reforms were initiated by the government, American democracy was likely to fail.

Theodore Roosevelt, 1858–1919

———

Adrian Lamb (1901–1988), after Philip Alexius de László
Oil on canvas, 132.7 × 101.6 cm (52¼ × 40 in.), 1967
After 1908 original
Gift of the Theodore Roosevelt Association
NPG.68.28

Theodore Roosevelt

———

Sally James Farnham (1869–1943)
Bronze relief, 52.7 cm (20¾ in.) height, without mount, 1906
NPG.74.16

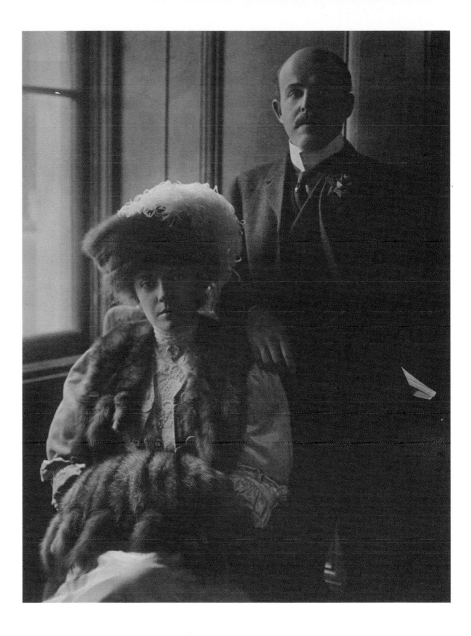

Nicholas and Alice Roosevelt Longworth

––––––

Edward S. Curtis (1868–1952)
Platinum print, 23 × 17.2 cm (9¹⁄₁₆ × 6¾ in.), 1906
Gift of Joanna Sturm
NPG.81.128

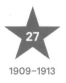

WILLIAM HOWARD TAFT

William Howard Taft initially was determined to follow in the footsteps of his predecessor, Theodore Roosevelt (p. 117), in the implementation of domestic reform, but Taft—an indecisive leader—was largely unsuccessful in meeting this goal. When the president presented his tariff reform package, Congress put forth more than eight hundred amendments that essentially made the reform impossible to pass, and Taft did nothing to object. He did, however, achieve one significant piece of reform legislation: the Mann-Elkins Act of 1910, which regulated destructive competition and unfair trade practices. In addition, ninety-nine trust prosecutions were conducted while Taft was in office. Nevertheless, by the halfway point of his presidency, he had become heavily influenced by conservative businessmen who criticized the effects of trust-busting on the national economy. In the end, Taft reversed his position on tariff reform and therefore alienated progressives who viewed high tariffs as the worst offending characteristic of trusts.

William Howard Taft, 1857–1930

———

William Valentine Schevill (1864–1951)
Oil on artist board, 84.9 × 74.9 cm (33⅞₆ × 29½ in.), c. 1910
Gift of William E. Schevill
NPG.72.25

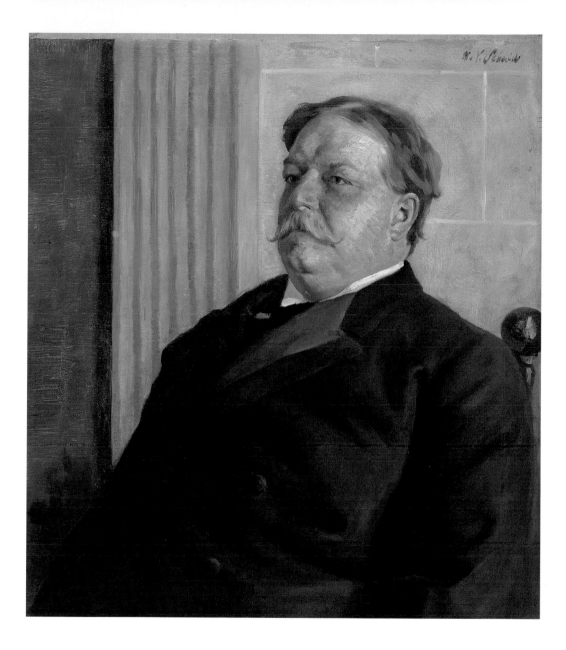

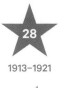

WOODROW WILSON

Elected to the White House after winning wide acclaim as the reforming governor of New Jersey, Woodrow Wilson sought to curb abusive business practices and improve conditions for workers. In spite of his progressive reforms, he did not support women's suffrage, effectively protracting that fight through 1919. Moreover, his international idealism during and after World War I—he sought to create a world order that would prioritize peace over national self-interest—was not supported either at home or abroad, and the European powers' imposition of a punitive settlement on Germany sowed the seeds for another war. Wilson's disappointment was compounded by his failure to convince his own country to support the League of Nations, an international organization he had conceived as the best hope for avoiding future wars. Having suffered a stroke while campaigning for American entry into the league, he left office in 1921, broken in both health and spirit. While Wilson once had an unalloyed reputation as a champion of liberal values, recent scrutiny has drawn attention to his regressive actions concerning both civil liberties and civil rights.

John Christen Johansen, a Danish-born artist living in Chicago, was one of several painters who made portraits of the dignitaries involved in the Treaty of Versailles, which ended World War I. This sketch, which Johansen made for a much larger group portrait documenting the signing of the treaty, in June 1919, depicts Wilson just months before his debilitating stroke.

Woodrow Wilson, 1856–1924

———

John Christen Johansen (1876–1964)
Oil on canvas, 77 × 63.8 cm (30⁵⁄₁₆ × 25⅛ in.), c. 1919
Gift of an anonymous donor
NPG.65.84

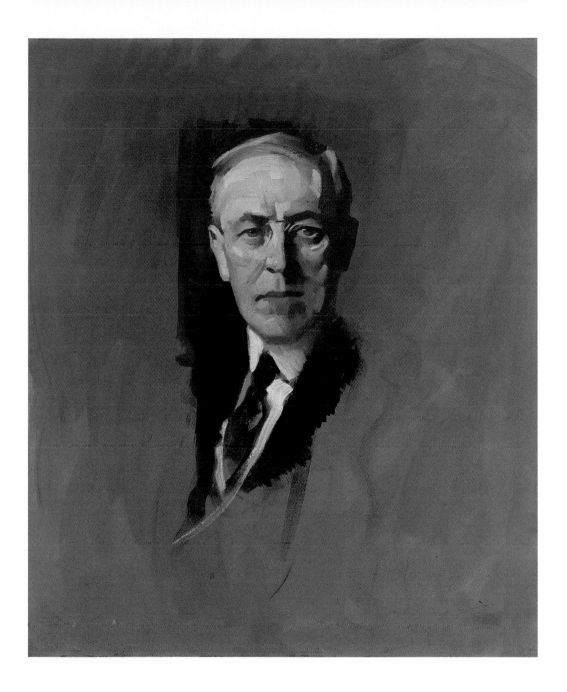

WARREN G. HARDING

After an era of upheaval, including sweeping social reforms and the violent conflicts of World War I, the citizens of the United States turned to Warren G. Harding, a former governor and senator from Ohio (the "Cradle of Presidents"), to calm the waters in 1920. Harding had made "normalcy" the keynote of his campaign for the presidency, and while the meaning of the newly coined term was uncertain, it implied no unsettling changes.

During Harding's presidency, the United States succeeded in slowing a naval arms race with Japan and Great Britain, but in doing so, it agreed to provisions that in effect ceded naval control of the western Pacific to the Japanese, which would lead to later conflicts. In fact, mistake after mistake characterized Harding's presidency. An inept judge of character, he entrusted corrupt cronies with positions of power. Unsurprisingly, his administration became tainted by scandal, although exactly how much Harding knew of it remains under speculation; he died in office just as stories of wrongdoing were coming to the attention of the public.

Warren G. Harding, 1865–1923

———

Margaret Lindsay Williams (1888–1960)
Oil on canvas, 135.9 × 99.7 cm (53½ × 39¼ in.), 1923
NPG.66.21

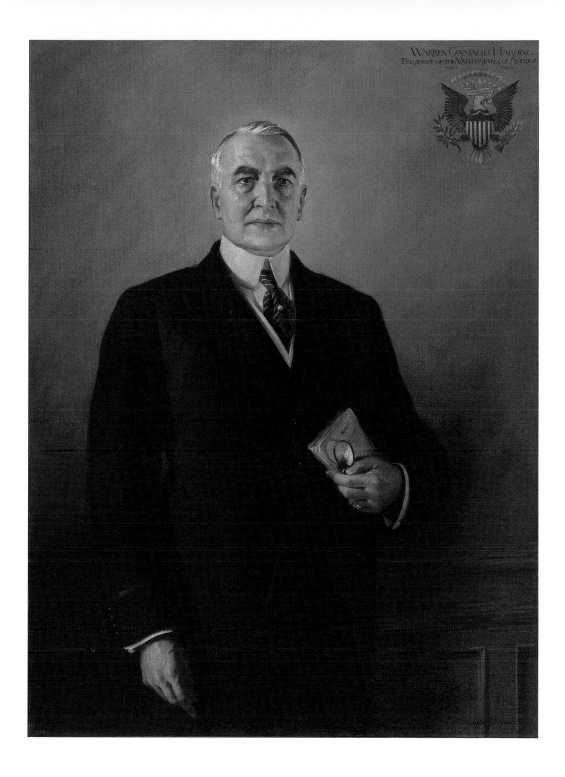

WARREN GAMALIEL HARDING
PRESIDENT OF THE UNITED STATES OF AMERICA
1920 1923

CALVIN COOLIDGE

At a time that saw the growth of big government and an increasingly powerful presidency, Calvin Coolidge stands out as the last genuinely "small-government" conservative to serve as president. Coolidge was famously taciturn, earning him the nickname "Silent Cal," and his demeanor informed a governing philosophy that eschewed intervention except in a civil emergency. As governor of Massachusetts, Coolidge's independence and handling of the Boston police strike of 1919, an emergency that called for executive leadership, made him an attractive candidate for national office, and he became Harding's vice president in 1921. After Harding's sudden death in 1923, Coolidge ascended to the presidency, and his manner and personal rectitude helped restore the people's trust in the government after the scandal-ridden Harding administration. He handily won election to a full term as president in 1924. Although Coolidge played up his "silent" reputation, he had a dry sense of humor, and he and his wife, Grace, entertained more than any previous presidential couple. He did not seek reelection in 1928.

Calvin Coolidge, 1872–1933

———

Joseph E. Burgess (1890–1961), after Ercole Cartotto
Oil on canvas, 143.5 × 97.1 cm (56½ × 38¼ in.), 1956
Gift of the Fraternity of Phi Gamma Delta
NPG.65.13

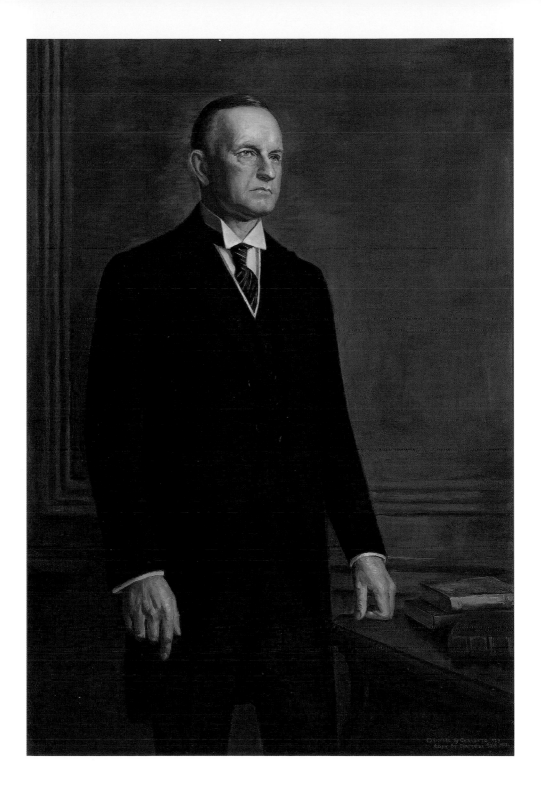

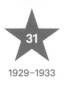

HERBERT HOOVER

Trained as a mining engineer, Herbert Hoover was known as a public intellectual and a problem solver. As such, he embodied the new class of expert who applied rationality to social issues. During and after World War I, his management of European food relief was a model of public administration that resolved a pressing social need.

The Great Depression, however, which began early in his presidency, proved to be beyond Hoover's control and understanding. A believer in the power of private initiative, he hesitated to involve the federal government in relief programs or the regulation of businesses. Lengthening breadlines and escalating joblessness finally convinced him to take action, but his measures were too little, too late. Consequently, he was defeated by a huge margin in his 1932 reelection bid. It is hard to know what Hoover could have done differently, but the fact that the Depression started on his watch haunted Republican candidates for decades. Yet Hoover went on to play an important role in 1947 as chairman of the Hoover Commission, tasked to recommend ways to streamline the federal government so as to save money and increase efficiency.

This portrait initially was intended for the cover of *Time* magazine. Hoover was slow to respond to requests for sittings, however, and the portrait was never published.

Herbert Hoover, 1874–1964

———

Douglas Chandor (1897–1953)
Oil on canvas, 114.3 × 96.5 cm (45 × 38 in.), 1931
NPG.68.24

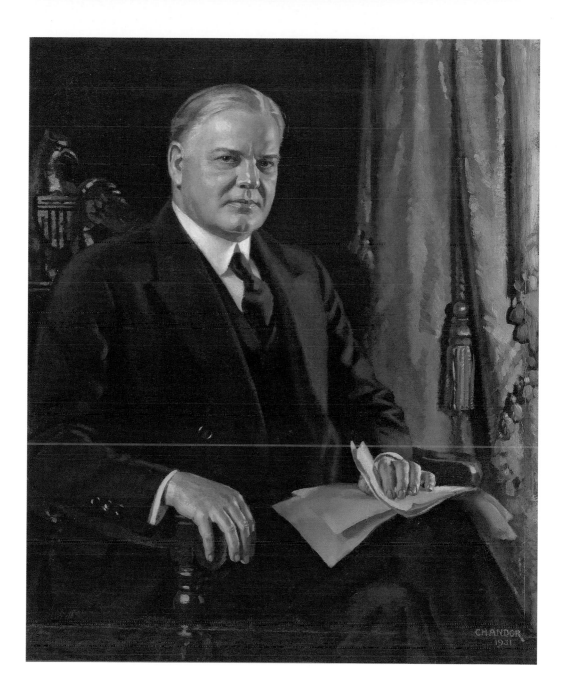

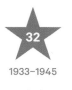

FRANKLIN D. ROOSEVELT

Franklin D. Roosevelt overcame an incapacitating case of polio to lead the country through a devastating financial crisis, the likes of which were unparalleled in the modern world economy. He was the driving force behind the New Deal—the ambitious system of government programs that ushered in public works projects, government regulation of banking and business, financial reforms, and federal relief. Through the medium of radio, Roosevelt was able to occupy a special niche in the minds of the American people. His fireside chats helped convince the nation that, as he put it in his first inaugural address, "the only thing we have to fear is fear itself."

As World War II broke out in Europe, Roosevelt broke tradition by seeking a third term, arguing that one does not change horses in midstream. When the United States entered the conflict, Roosevelt transitioned from "Dr. New Deal to Dr. Win the War," devoting all of his considerable energies to the alliance that would defeat the Axis.

An unprecedented program of governmental military spending helped erase the last vestiges of the Depression even as it provided the materiel that would win the war. In his diplomatic summits with Britain's Winston Churchill and the Soviet Union's Joseph Stalin, Roosevelt not only prosecuted the war but also helped lay the groundwork for the postwar world.

Roosevelt was elected an unprecedented four times. His death in 1945 shocked the nation and inspired a period of widespread mourning among the American people, many of whom had known no other president in their lifetimes.

In March 1945, Douglas Chandor spent several days at the White House to make sketches for a group portrait of Roosevelt, Churchill, and Stalin to mark their conference the previous month at Yalta, a resort on the Black Sea. The artist wished the painting to be a "conversation about peace," but it was never realized because Stalin refused to sit for his portrait. Chandor based this painting on his sketches of Roosevelt.

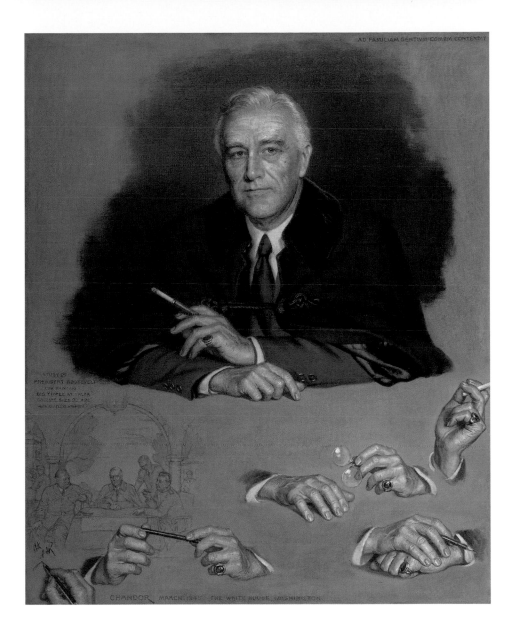

Franklin D. Roosevelt, 1882–1945

———

Douglas Chandor (1897–1953)
Oil on canvas, framed 136.2 × 115.9 cm (53⅝ × 45⅝ in.), 1945
NPG.68.49

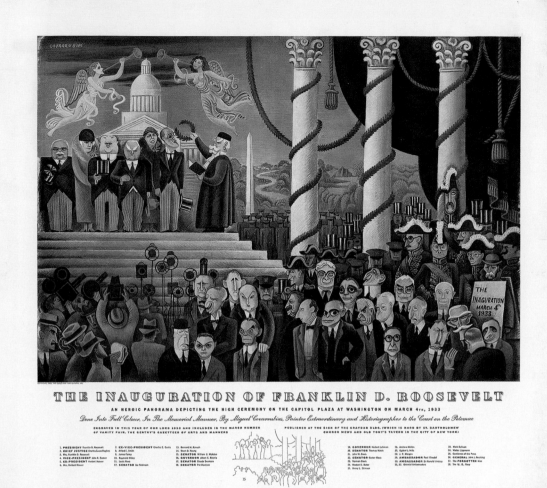

The Inauguration of Franklin D. Roosevelt

————

Miguel Covarrubias (1904–1957)
Color halftone, 34.2 × 48.3 cm (13⁷⁄₁₆ × 19 in.), 1933
NPG.82.43

1.	President Franklin D. Roosevelt	20.	Senator Thomas Walsh
2.	Chief Justice Charles Evans Hughes	21.	John W. Davis
3.	Mrs. Franklin D. Roosevelt	22.	Senator Carter Glass
4.	Vice-President John N. Garner	23.	Norman Davis
5.	Ex-President Herbert Hoover	24.	Newton D. Baker
6.	Mrs. Herbert Hoover	25.	Henry L. Stimson
7.	Ex-Vice-President Charles E. Curtis	26.	Andrew Mellon
8.	Alfred E. Smith	27.	Ogden L. Mills
9.	James Farley	28.	J. P. Morgan
10.	Raymond Moley	29.	Ambassador Paul Claudel
11.	Louis Howe	30.	Ambassador Sir Ronald Lindsay
12.	Senator Joe Robinson	31, 32.	Oriental Ambassadors
13.	Bernard M. Baruch	33.	Mark Sullivan
14.	Owen D. Young	34.	Walter Lippman
15.	Senator William G. McAdoo	35.	Gentlemen of the Press
16.	Governor Albert C. Ritchie	36.	General John Pershing
17.	Senator Claude Swanson	37.	The Forgotten Man
18.	Senator Pat Harrison	38.	The U.S. Navy
19.	Governor Herbert Lehman		

Franklin D. Roosevelt

———

George Tames (1919–1994)
Gelatin silver print, 35.1 × 27.4 cm (13¹³⁄₁₆ × 10¹³⁄₁₆ in.), 1944
Gift of Frances O. Tames
NPG.94.204

Franklin D. Roosevelt

———

Edward Steichen (1879–1973)
Gelatin silver print, 24.8 × 19.7 cm (9¾ × 7¾ in.), 1933
Bequest of Edward Steichen
NPG.82.85

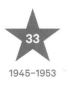

HARRY S. TRUMAN

This portrait was painted shortly after Harry Truman became president following Franklin Roosevelt's death on April 12, 1945. Truman's ascension was untimely, in part because he seemed unprepared for the complexities of the job. Truman had risen to the Senate owing largely to his abilities to get along and go along with leaders of the Democratic Party; from Missouri, he was part of the Democratic machine but had evidenced little ability beyond loyalty to party. Upon learning of Roosevelt's death, he said he felt as if "the moon, the stars, and all the planets" had fallen on him, but he pledged to do his best.

In the summer of 1945, Truman faced the daunting task of ending the war in the Pacific and negotiating with the increasingly belligerent Soviet Union. Facing Soviet expansion, he endorsed the Marshall Plan, the strategy that helped rebuild war-torn Europe. He ran for president in his own right in 1948, defeating the much-favored Thomas Dewey in a stunning upset. His presidency began to founder as he faced crises at home and abroad, notably the Korean War (1950–53). By the time he left office, his reputation had sunk to a near record low in the polls. Yet over time, Truman has been better appreciated for his pragmatic flexibility, his firmness in standing up to the Soviets, his homespun personality, and particularly his honesty.

Truman sat for artist Jay Wesley Jacobs five times in May and August 1945. Jacobs created two portraits; this one, commissioned by Assistant Treasury Secretary Lawrence Wood Robert Jr., was intended for the U.S. Senate but remained in the Robert family. Jacobs made a similar, slightly smaller portrait for the Truman family, without the flags in the background. That portrait, a favorite of the president's daughter, Margaret Truman, remains with the family.

Harry S. Truman, 1884–1972

———

Jay Wesley Jacobs (1898–1968)
Oil on canvas, 102.1 × 81.6 cm (40³⁄₁₆ × 32⅛ in.), 1945
Partial gift of the William T. Kemper Foundation
NPG.2014.14

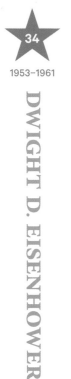

DWIGHT D. EISENHOWER

In 1952, General Dwight D. Eisenhower was courted by both political parties to run for president. A triumphant World War II hero, Eisenhower was a proven leader, armed with a ready smile and an adept organizational ability that enabled him to deal with all the diverse interests and fractious personalities of the Allies, from General George S. Patton to France's Charles de Gaulle. Americans liked "Ike," who ran as a Republican, and elected him to two terms. As president, Eisenhower ended the Korean War and maintained an uneasy balance with the Soviet bloc. A moderate conservative, he was cautious on issues of civil rights and warned of the growth of a "military-industrial complex" that threatened both government and American values. Once criticized as too passive a president, Eisenhower now draws widespread praise for his consensual and effective style of leadership. His eight years in office were a time of peace and prosperity that included major domestic achievements such as the construction of the interstate highway system and the beginnings of desegregation in the South. Moreover, Eisenhower consistently accomplished what few modern presidents seem able to do: he balanced the national budget.

Dwight D. Eisenhower, 1890–1969

———————

Thomas E. Stephens (1886–1966)
Oil on canvas, 188 × 157.5 cm (74 × 62 in.), 1955
Lent by the Dwight D. Eisenhower Presidential Library and Museum
National Archives and Records Administration, Abilene, Kansas

JOHN F. KENNEDY

When John F. Kennedy was assassinated in 1963, the country experienced a collective sense of grief that it had not known since the death of Abraham Lincoln. Many Americans found it hard to cope with the sudden loss of this youthful, energetic president whose gracious speeches had inspired citizens to achieve high ideals. In his shortened tenure as president, Kennedy proposed landmark civil rights legislation, created the Peace Corps, and advanced the goal of landing a man on the moon. In foreign policy, his administration peacefully resolved a dramatic stand-off with the Soviet Union over the presence of missiles in Cuba, yet Kennedy was not reluctant to project American military power, overseeing the beginnings of the buildup of the American presence in Vietnam.

Elaine de Kooning, known for her gestural portraits, was chosen in 1962 to create a portrait of Kennedy for the Harry S. Truman Presidential Library. She had several informal sessions with Kennedy in Palm Beach, Florida, in December 1962 and January 1963. She was so moved by Kennedy that over the next ten months she created dozens of drawings and paintings of him. De Kooning said she loved "the feeling of the outdoors he radiated" and noted that "on the patio . . . where we often sat . . . he was enveloped by the green of the leaves and the golden light of the sun." This image aptly captures Kennedy's restless energy.

John F. Kennedy, 1917–1963

———

Elaine de Kooning (1918–1989)
Oil on canvas, 260.4 × 111.8 cm (102½ × 44 in.), 1963
NPG.99.75

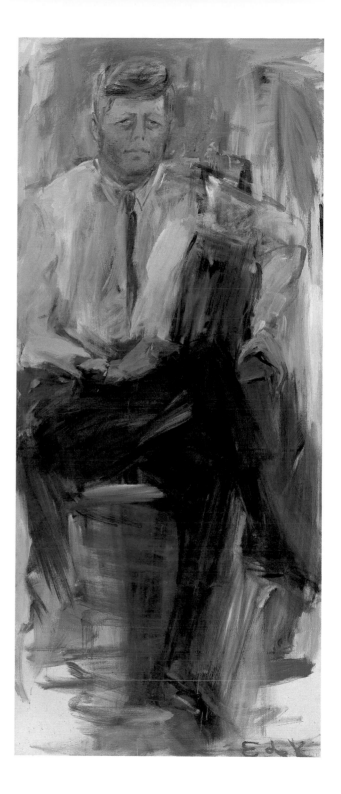

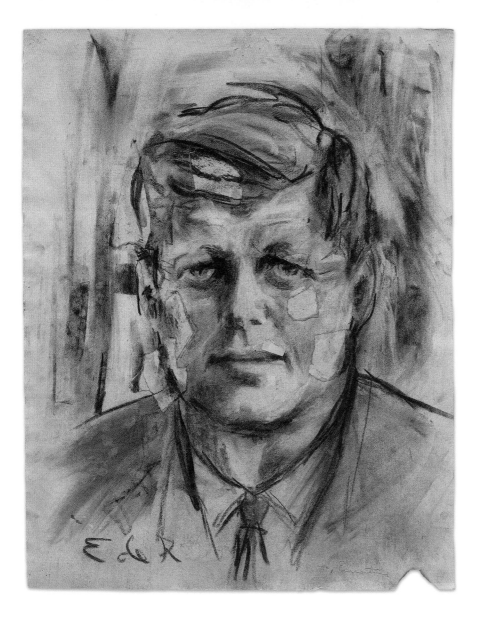

John F. Kennedy

———————

Elaine de Kooning (1918–1989)
Charcoal and paper collage on paper, 66.4 x 50.8 cm (26⅛ x 20 in.), 1963
A gift from Elaine to Ernestine Lassaw, donated by Denise Lassaw
in honor of her two mothers
NPG.2015.132

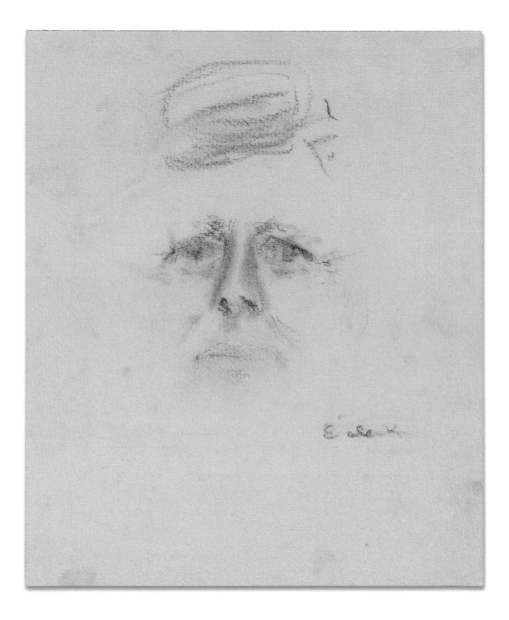

John F. Kennedy #3

————

Elaine de Kooning (1918–1989)
Charcoal on paper, 43.2 × 35.6 cm (17 × 14 in.), 1963
Gift of Maud Fried-Goodnight
NPG.2016.15

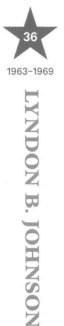

LYNDON B. JOHNSON

Sworn in after the assassination of President Kennedy, Lyndon B. Johnson would become one of the nation's most ruthless, ambitious, and idealistic chief executives. In office, he worked long hours and interacted closely with members of Congress to ensure the creation of his "Great Society": an America where prosperity and opportunity would be provided through the benevolent efforts of a strong and active federal government. A master manipulator and a veteran legislator, Johnson was responsible in part for major legislation on antipoverty, education, and civil rights. He decisively won a full term as president in 1964, yet his legacy was permanently tarnished when he tried to apply a similarly aggressive style to his foreign policy in Vietnam. Johnson's efforts to fight communism in the region resulted in the deaths of more than fifty-eight thousand Americans and signaled the end of his own political career. With his approval rating plummeting, Johnson declined to run for reelection in 1968. Nevertheless, the war continued for another seven years.

Peter Hurd was commissioned to make Johnson's official portrait for the White House. The president sat several times for the artist, but when he saw the finished painting, he declared it "the ugliest thing I ever saw." With Johnson refusing to accept the painting, Hurd kept it and eventually gave it to the National Portrait Gallery when the museum opened in 1968. In exchange, museum leaders promised not to show it publicly until after the president left office.

Lyndon B. Johnson, 1908–1973

———

Peter Hurd (1904–1984)
Tempera on wood, 120.7 × 94.6 cm (47½ × 37¼ in.), 1967
Gift of the artist
NPG.68.14

RICHARD M. NIXON

Richard Nixon had one of the most complex and controversial political careers of the post–World War II era. Coming of political age during the Cold War, he was a Californian who used national security issues, including the question of alleged Soviet infiltration of the government, to gain national prominence in Congress, which helped earn him his position as Eisenhower's two-term vice president. Nixon's career appeared to be over after he failed to win the presidency in 1960 and the California governorship in 1962. Yet he made a remarkable recovery, and as the Democratic Party fractured over the Vietnam War and civil rights, Nixon won the presidency in the midst of social turmoil in 1968.

While he focused on foreign policy—prosecuting the war in Southeast Asia, establishing détente with Russia, and opening relations with China—his domestic agenda was, in retrospect, surprisingly liberal: he oversaw the creation of the Environmental Protection Agency, advocated consumer protections, and proposed a national health-care plan. Nixon was ultimately brought down by his secretive and manipulative personality: the scandal over the break-in at Democratic National Committee offices at the Watergate building and political dirty tricks morphed into a crisis over presidential misconduct, and he was forced to resign—the first president to do so—in 1974.

In 1968, *Look* magazine hired Norman Rockwell to portray the newly elected president, who posed at New York's Plaza Hotel. Rockwell admitted that he intentionally flattered Nixon in this portrait, as the artist found the president's appearance to be troublesomely elusive. If he was going to err in his portrayal, Rockwell said, he wanted it to be at least in a direction that would please his subject.

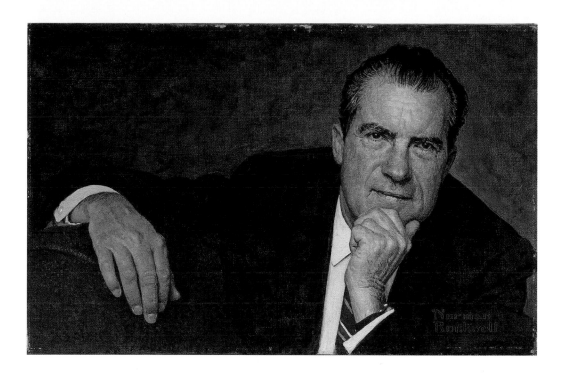

Richard M. Nixon, 1913–1994

———

Norman Rockwell (1894–1978)
Oil on canvas, 46.4 × 66.7 cm (18¼ × 26¼ in.), 1968
Donated to the people of the United States of America
by the Richard Nixon Foundation
NPG.72.2

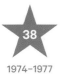
GERALD R. FORD

Gerald R. Ford's rise to the presidency was as unexpected as it was historic. Appointed vice president by Richard Nixon after Spiro Agnew resigned in 1973, Ford was then sworn in as president on August 9, 1974, after Nixon resigned. Thus he became the first president to hold office without having been elected by the people. Upon assuming the presidency, Ford announced, "Our long national nightmare is over," and he immediately set about restoring credibility to America's highest office. In a controversial gesture to heal the nation—and also to prevent a lengthy trial—he pardoned Nixon of any wrongdoing. He also offered amnesty to Vietnam War deserters and draft evaders. Ford would pay a price for his leniency in his reelection campaign in 1976. Although he staved off a bitter challenge by Ronald Reagan for the Republican nomination, he lost the support of many unforgiving voters, who voted for Democrat Jimmy Carter.

This likeness by Everett Raymond Kinstler was painted at Ford's request specifically for the National Portrait Gallery. The artist based the portrait on sketches he had made of the president in the late 1970s, when he was working on Ford's official likeness for the White House.

Gerald R. Ford, 1913–2006

———

Everett Raymond Kinstler (born 1926)
Oil on canvas, 111.1 × 85.4 cm (43¾ × 33⅝ in.), 1987
Gift of the Gerald R. Ford Foundation
NPG.87.245

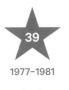

JAMES CARTER

When Americans elected Jimmy Carter in 1976, they were voting for a positive change in executive leadership. Burdened by an escalating cost of living and tired of scandal-ridden politics, they saw Carter as a fresh face who would, in his words, make government "as good as the American people." A born-again Christian, Carter touted his human decency to heal the divisions of post-Vietnam American society while also promising to fix the economy. Stemming high inflation, however, proved to be harder than he had predicted. Nor could he do much to ease the ongoing energy crisis that had been instigated by the cartel of oil-producing nations in the Middle East and was characterized by a shortage of gas for consumers at the pumps and high costs for home heating oil. In 1978, Carter successfully brokered a landmark peace accord between Egypt and Israel, but the Iranian hostage crisis of 1979, spurred by U.S. support of the unpopular Shah of Iran, crippled the last year of his administration. He lost his reelection bid to Ronald Reagan in 1980.

In this portrait, by Robert Templeton, Carter is shown standing in the Oval Office, which is furnished as it was during his tenure. The donkey statuette on his desk was a gift from the Democratic National Committee.

James Carter, born 1924

———

Robert Templeton (1929–1991)
Oil on canvas, 235 × 142.2 cm (92½ × 56 in.), 1980
Partial gift of the 1977 Inauguration Committee
NPG.84.154

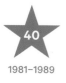

40

1981–1989

RONALD REAGAN

A former actor and governor of California, Ronald Reagan was a formidable politician whose rise exemplified the shift in American demographics toward the West and Southwest. Within the Republican Party, his ascension marked the revitalization of the conservative western wing of the party, which many thought had died with the defeat of Barry Goldwater in 1964. As president, Reagan challenged many of the liberal programs that had dominated the federal government since the New Deal, and throughout his presidency he strove to cut the size of government. Reagan decreased government regulation of the private sector, enforced the largest tax cut in U.S. history, and promoted unrestricted free-market activity. Reagan held steadfast to these ideas: when air traffic controllers went on strike in 1981, he fired them without hesitation and sent military personnel into control towers to keep commercial flights operating unhindered.

He unapologetically reduced social welfare programs and encouraged a conservative social ethic regarding the role of religion in public life and reproductive rights, stances that led him to largely ignore the burgeoning AIDS crisis. In foreign policy, Reagan cast himself as the ultimate Cold Warrior, calling the Soviet Union an "evil empire" and pushing aggressive policies such as the high-tech Strategic Defense Initiative. And yet his diplomatic partnership with Soviet leader Mikhail Gorbachev produced sweeping arms accords and new levels of cooperation and openness between the two countries. In the end, Reagan's policies helped pave the way for a peaceful end to the Cold War and the fall of the Soviet Union just a few years after he left office.

Ronald Reagan, 1911–2004

———————

Everett Raymond Kinstler (born 1926)
Oil on canvas, 91.5 × 74 cm (36 × 29⅛ in.), 1991
Gift of Everett Raymond Kinstler
NPG.93.384

Ronald Reagan

———

Aaron Shikler (1922–2015)
Oil on paper, 63.5 × 41.3 cm (25 × 16¼ in.), 1980
Gift of *Time* magazine
NPG.84.TC140

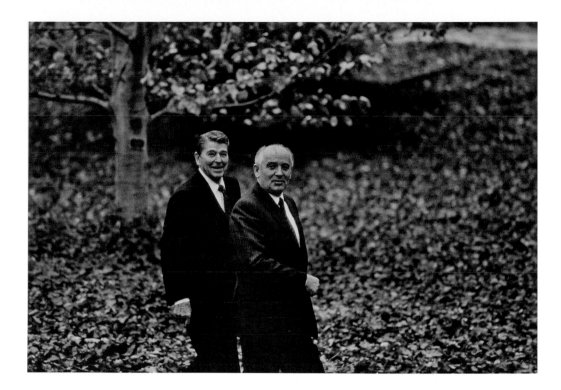

Ronald Reagan and Mikhail Gorbachev

———————

Diana Walker (born 1942)
Chromogenic print, 28 × 40.6 cm (11 × 16 in.), 1987
Gift of Diana Walker
S/NPG.95.110

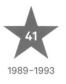

GEORGE H. W. BUSH

A decorated naval aviator in World War II, George H. W. Bush went on to a successful career in the oil industry of West Texas. Subsequently, high-level positions—not least directorship of the Central Intelligence Agency—defined one of the most distinguished careers in government, including a turn as Ronald Reagan's vice president. With this résumé, he was the inevitable successor to Reagan, and he easily won the 1988 election in a race that hinged on foreign policy and Bush's advocacy of American power. He successfully managed the complicated transitions prompted by the collapse of the Soviet Union and the end of the Cold War, supporting U.S. restraint and flexibility during this critical time. His biggest crisis and most successful test was his marshaling of a U.S.-backed military coalition to eject Iraq's army from Kuwait after the invasion of that nation in 1990.

The First Gulf War, as it is now known, was a dramatic and comprehensive success, one that signaled the recovery of the American military after the war in Vietnam. Despite the victory in the Persian Gulf, many Americans could not forgive Bush for breaking his pledge not to raise taxes, and voters were frustrated by his administration's inability to bring the nation out of an economic recession. Brought down by these domestic matters, Bush was easily defeated by Bill Clinton in 1992.

George H. W. Bush, born 1924

———

Ronald N. Sherr (born 1949)
Oil on canvas, 125.1 × 86.7 cm (49¼ × 34⅛ in.), 1994–95
Gift of Mr. and Mrs. Robert E. Krueger
NPG.95.120

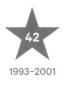

WILLIAM J. CLINTON

The first baby-boomer president, Bill Clinton came to national attention when, at age thirty-two, he claimed the Arkansas governorship. In this position, he emerged as one of the leading reform governors of the Democratic Party. As president, his administration played a crucial part in curbing the massive federal spending deficits that had soared in the 1980s, even achieving, for the first time since the 1960s, a surplus in revenues. His other accomplishments include welfare reform and a successful U.S.-led NATO intervention in the Balkans. Proposals such as universal health care, however, failed, and Clinton's administration was plagued by charges of criminal real-estate schemes (including "Whitewater") and the consequences of his affair with a White House intern. His denial under oath about the extramarital relationship led to his impeachment, but he was not convicted in the Senate trial. Despite the scandal, Clinton was successful in refashioning the Democratic Party, making it more centrist and thus better able to compete with the Republicans on issues of foreign policy and the economy.

Chuck Close begins all of his paintings by taking a photograph of his subject, in this case an image made in August 2005 for a *New York* magazine cover. He then creates grids on both the canvas and the photograph to replicate the information contained in the photograph with a series of abstract modules. He first photographed Bill Clinton at the White House in 1996 and has since made additional images of him in a variety of media.

William J. Clinton, born 1946

———————

Chuck Close (born 1940)
Oil on canvas, 275.6 × 213.4 cm (108½ × 84 in.), 2006
Lent by Ian and Annette Cumming Collection

43

2001–2009

GEORGE W. BUSH

Like John Quincy Adams of Massachusetts (p. 73), Texas-bred Republican George W. Bush was the eldest son of a president. Also like Adams, Bush was elected in a close and controversial election against a Democratic vice president. Bush's victory over Al Gore was ultimately decided by a Supreme Court ruling with regard to recounting votes in Florida. Expecting that his presidency would center largely on domestic issues, Bush instead found his two terms in office marked by a series of cataclysmic events. Above all, there were the terrorist attacks of 9/11, which necessitated an immediate response to reassure the American public and led to the development of policies for dealing with the sudden menace of al-Qaeda and worldwide terrorism. In response, Bush created the Department of Homeland Security, mounted major military actions in Afghanistan, and invaded Iraq, toppling its dictator, Saddam Hussein. At home, Bush had to deal with the devastation wrought by Hurricane Katrina and a financial crisis during his second term. Despite his efforts to safeguard the country's security and welfare, the whipsaw effect of so many crises—and criticism that his responses had been misguided or ineffectual—meant that Bush left office with his reputation at a low ebb.

To create this painting for the National Portrait Gallery, the president selected Robert A. Anderson, a Connecticut portraitist and a Yale classmate who had depicted Bush previously for the Yale Club in New York. For this portrait, the president requested an informal image and posed for the artist at Camp David, the presidential retreat in Maryland.

George W. Bush, born 1946

———

Robert A. Anderson (born 1946)
Oil on canvas, 132.4 × 92.7 cm (52⅛ × 36½ in.), 2008
Gift of American Fidelity Foundation, J. Thomas and Stefanie Atherton, William S. and Ann Atherton, Dr. Jon C. and Jane G. Axton, Dr. Lee and Sherry Beasley, Thomas A. Cellucci, A. James Clark, Richard H. Collins, Edward and Kaye Cook, Don and Alice Dahlgren, Mr. and Mrs. James L. Easton, Robert Edmund, Robert and Nancy Payne Ellis, Dr. Tom and Cheryl Hewett, Dr. Dodge and Lori Hill, Pete and Shelley Kourtis, Tom and Judy Love, David L. McCombs, Tom and Brenda McDaniel, Herman and LaDonna Meinders, The Norick Family, Kenneth and Gail Ochs, Robert and Sylvia Slater, Richard L. Thurston, Lew and Myra Ward, Dr. James and Susan Wendelken, Jim and Jill Williams
NPG.2008.51

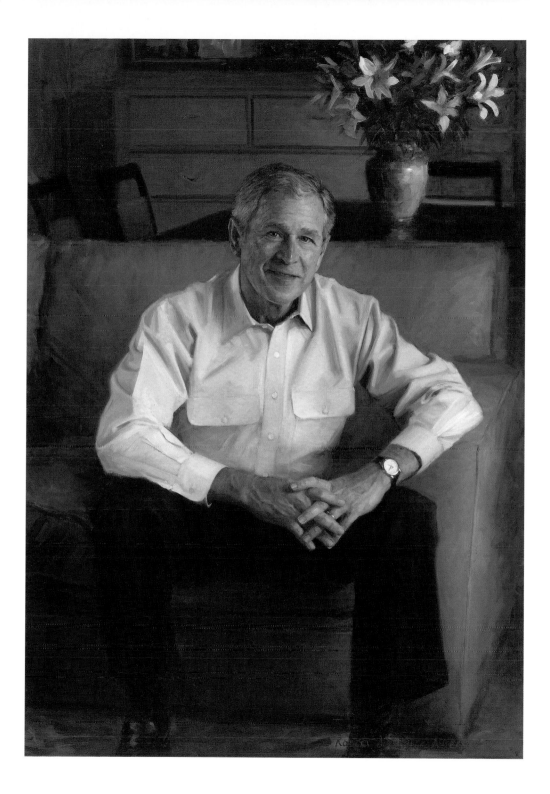

BARACK OBAMA

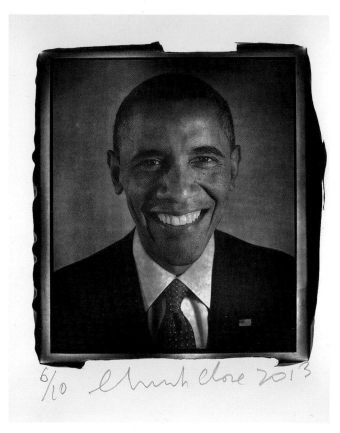

6/10 Chuck Close 2013

In 2008, Barack Obama made history as the first African American to be elected president, capping a meteoric rise and concluding a campaign that encouraged progress and optimism. For many, his election signaled increasing racial unity as well as an unprecedented feeling of hope for the future. When Obama entered office, the United States was undergoing its worst financial crisis since the Great Depression. Even with a sagging economy, however, he managed in 2010 to enact the Affordable Care Act, a major expansion of health-care benefits to uninsured Americans.

In foreign policy, Obama oversaw the drawdown of American troops in combat zones—a force reduction that was controversially replaced by an expansion of drone and aviation strikes. The mission to locate and kill al-Qaeda founder Osama bin Laden was successful, but a pledge to close the Guantánamo prison holding terrorism suspects went unrealized.

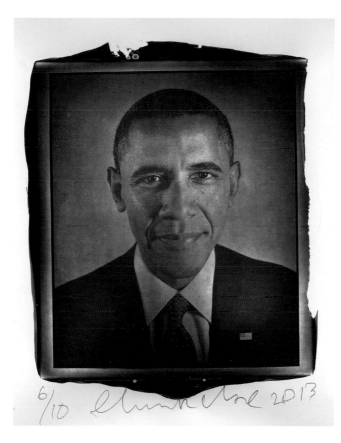

Barack Obama, born 1961

———————

Chuck Close (born 1940)
Woodburytypes, each 35.6 × 27.9 cm (14 × 11 in.), 2013
NPG.2017.6; NPG.2017.7

Despite the promise of his election and his accomplishments, the issue of Obama's race—and even his American citizenship—continued to be topics of discussion as the political culture began to fracture by the end of his second term.

At the end of each presidency, the National Portrait Gallery partners with the White House to commission the official portrait of the president. As this book goes to press, President Obama's official portrait is being created. It will enter the collection—and this exhibition—in 2018.

DONALD J. TRUMP

On November 8, 2016, real estate magnate, businessman, and reality television star Donald J. Trump completed a stunning rise to the presidency by defeating Hillary Rodham Clinton, a former senator and secretary of state, and the wife of former president Bill Clinton (p. 159), after one of the most volatile and divisive campaigns in recent memory. Tapping into a deep vein of populist American sentiment, Trump—to the surprise of the party's establishment figures—garnered the Republican nomination and became the first nonpolitician to win the presidency since Eisenhower.

Trump made his name in New York real estate, first inheriting the fortune developed by his realtor father and then expanding his financial empire into other areas, such as airlines, casinos, and luxury hotels in the United States and abroad. He came to typify a buccaneering style of late-twentieth-century business practices that attracted both admiration and condemnation. Supporters saw Trump as a can-do businessman who cut through red tape and accepted practices to get things done. Detractors have pointed to how Trump has taken advantage of the bankruptcy laws as well as to the failure of many of his grandiose projects. But for Trump himself, all publicity is good publicity. Never short on confidence, he leveraged his business career through the media, including reality TV, to create the persona that launched his political career. The beginnings of his presidency have been tumultuous and even chaotic as he has begun to exercise political power. As was the case with his business career, the presidency of Donald Trump will be defined by the personality of the man himself.

The White House created this portrait for display in government offices. At the end of each presidency, the National Portrait Gallery and the White House partner to commission the official portrait of the president. The official portrait of Trump will be completed after he leaves office.

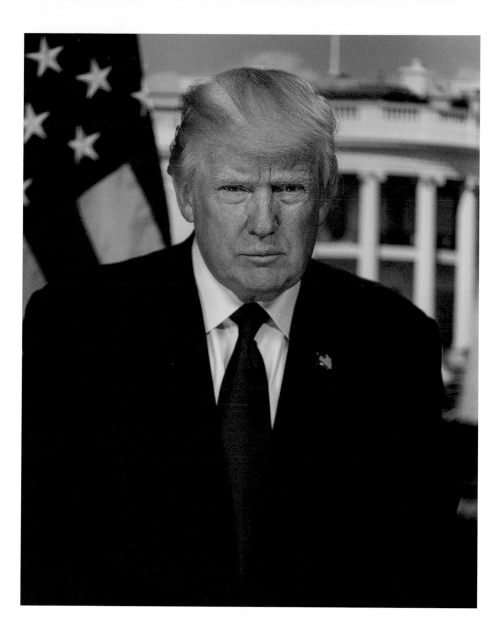

Donald J. Trump, born 1946

———

Shealah Craighead (born 1976)
Photograph, 2017
Lent by the White House, Washington, D.C.

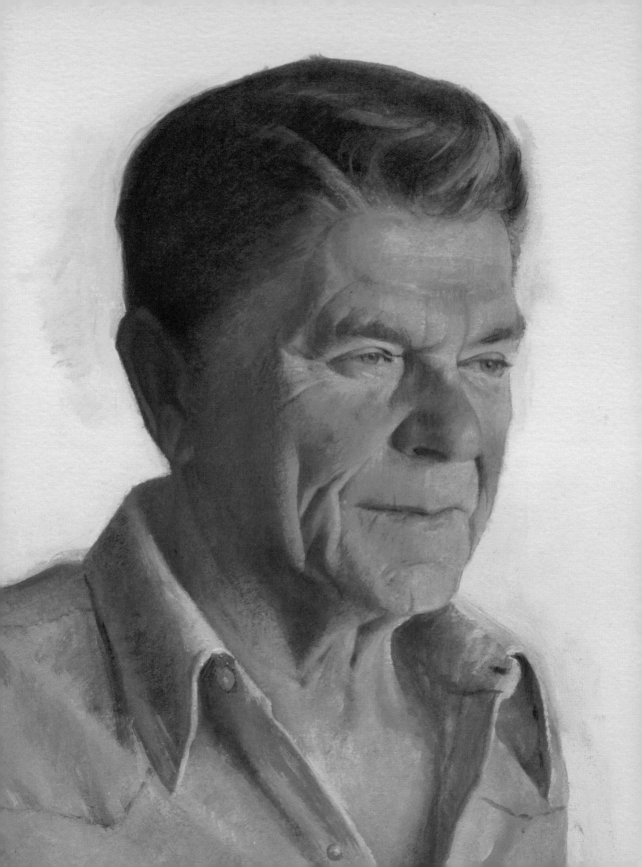

Measurements

Unless otherwise noted, measurements indicate stretcher size for paintings, height for sculpture, plate size for ambrotypes, image size for photographs, and sheet size for other works on paper.

Index of Subjects

Index of Artists

Unless otherwise noted, all images are from the National Portrait Gallery, Smithsonian Institution.

Published by Smithsonian Books in association with the National Portrait Gallery, Smithsonian Institution

Director: Carolyn Gleason
Project Managers: Dru Dowdy and Rhys Conlon, National Portrait Gallery
Managing Editor: Christina Wiginton
Project Editor: Laura Harger
Editorial Assistant: Jaime Schwender
Edited by Tom Fredrickson
Designed by Studio A

Library of Congress Cataloging-in-Publication Data

Names: National Portrait Gallery (Smithsonian Institution), author. | Ward, David C., 1952– author.
Title: America's presidents : National Portrait Gallery / David C. Ward ; with contributions by James G. Barber, Brandon Brame Fortune, and Kate C. Lemay.
Description: Washington, DC : Smithsonian Books in association with the National Portrait Gallery, 2018. | Includes index.
Identifiers: LCCN 2017034697 | ISBN 9781588346117 (paperback)
Subjects: LCSH: Presidents—United States—Portraits—Catalogs. | Portraits, American—Catalogs. | Portraits—Washington (D.C.)—Catalogs. | National Portrait Gallery (Smithsonian Institution)—Catalogs. | BISAC : BIOGRAPHY & AUTOBIOGRAPHY / Presidents & Heads of State. | ART / Collections, Catalogs, Exhibitions / Permanent Collections. | PHOTOGRAPHY / Subjects & Themes / Historical.
Classification: LCC E176.1 .N37 2018 | DDC 973.09/9—dc23
LC record available at https://lccn.loc.gov/2017034697

Manufactured in China, not at government expense
22 21 20 19 18 5 4 3 2 1